NEWCASTLE IN PHOTOGRAPHS

SIMON McCABE

AMBERLEY

First published 2022

Amberley Publishing
The Hill, Stroud
Gloucestershire, GL5 4EP

www.amberley-books.com

Copyright © Simon McCabe, 2022

The right of Simon McCabe to be identified as the Author of this work has been asserted in accordance with the Copyrights, Designs and Patents Act 1988.

ISBN 978 1 3981 0632 1 (print)
ISBN 978 1 3981 0633 8 (ebook)

British Library Cataloguing in Publication Data.
A catalogue record for this book is available from the British Library.

Typesetting by SJmagic DESIGN SERVICES, India.
Printed in the UK.

INTRODUCTION

One of my favourite features of Newcastle is its extraordinary blend of the old and new; the way Georgian stone, medieval cobbles and new millennium glass all stand gloriously in harmony. It was my aim to capture this contrast.

During my time photographing, the world had been hit by the Covid-19 pandemic and the once bustling streets of Newcastle were stripped bare.

I realised that, as well as capturing the city's contrasting buildings, I could capture this new disparity.

I hope you enjoy seeing Newcastle in this way – especially now we're enjoying its thriving return. For reassurance, social distancing and PPE guidelines were adhered to while photographing.

ABOUT THE AUTHOR

Simon McCabe is a Teesside-based photographer whose photography journey started over fifteen years ago. A close family member who was no longer able to travel said, 'Travel the world and take as many photos as you can, so I can see and experience the world through your eyes.' Since then, his experience, style and passion has been evolving and with each new challenge he has learnt new techniques in photography and editing. Nature, landscape and wedding photography are his main fields of experience.

Which of my photographs is my favorite? The one I'm going to take tomorrow.

Imogen Cunningham

Facebook: SimonMcCabePhotography
Instagram: Simonmccabe5
Email: Simon.mccabe2@gmail.com

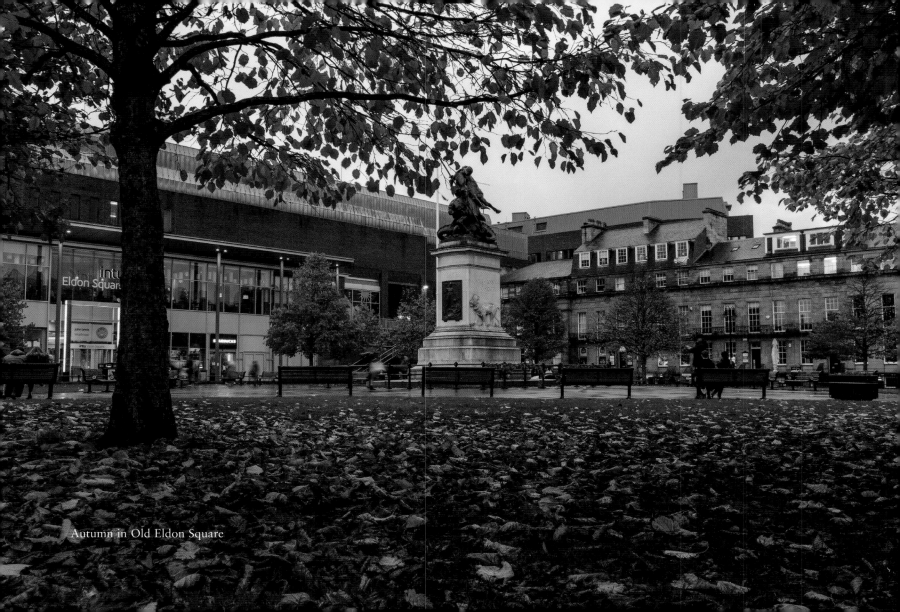

Autumn in Old Eldon Square

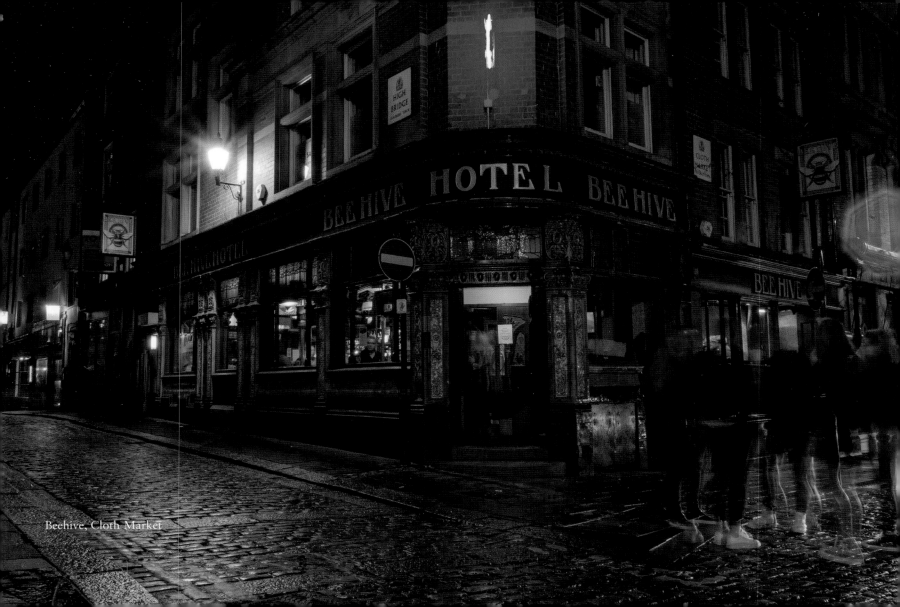

Beehive, Cloth Market

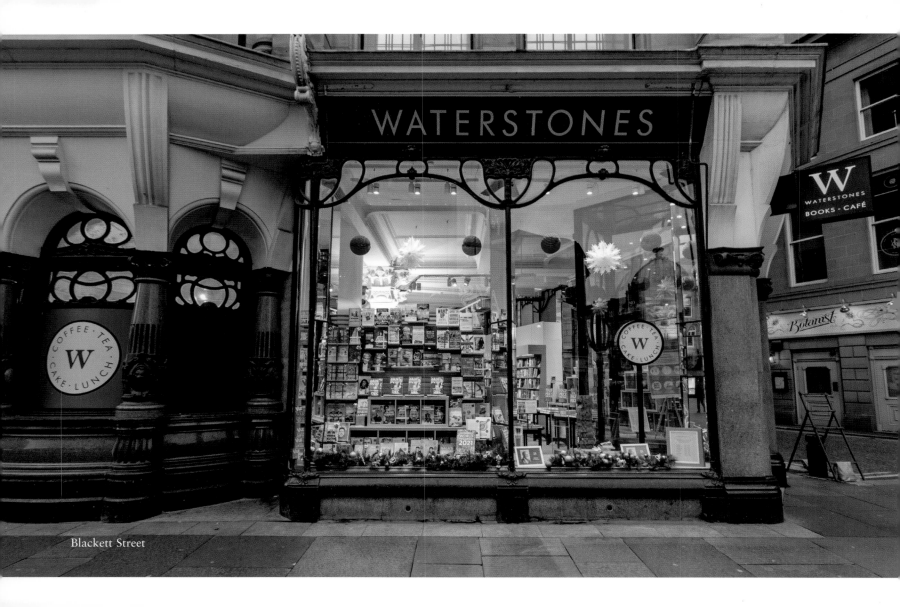

WATERSTONES

BOOKS · CAFÉ

Blackett Street

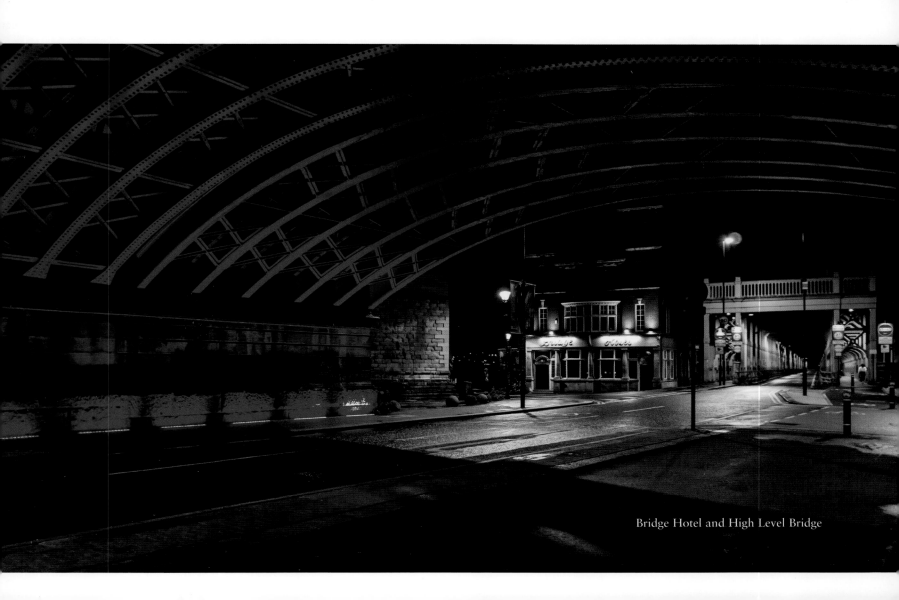

Bridge Hotel and High Level Bridge

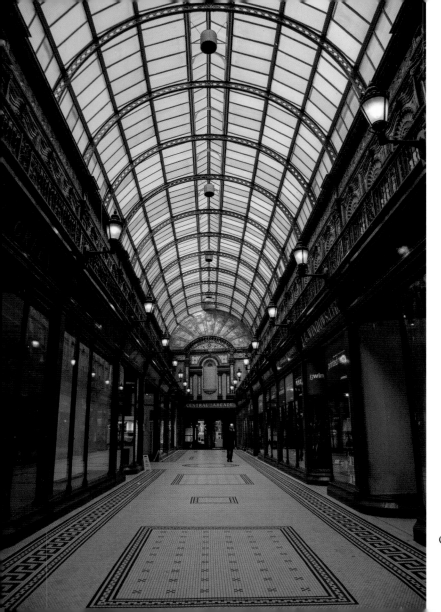

Central Arcade

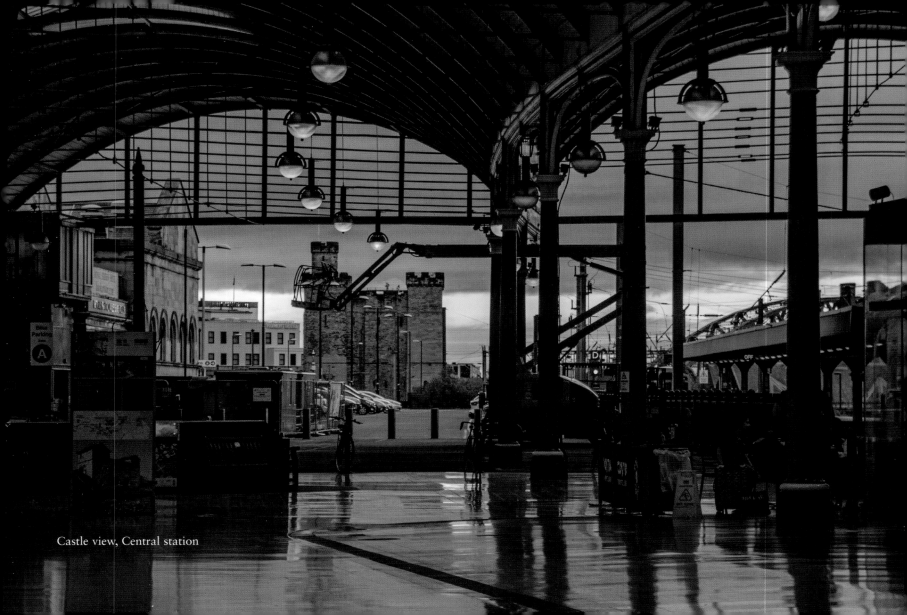

Castle view, Central station

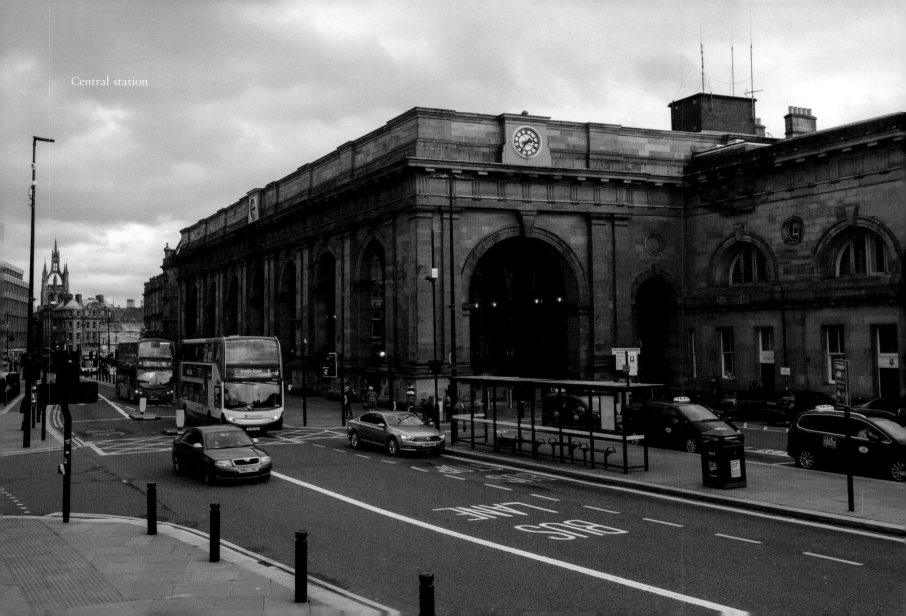

Central station

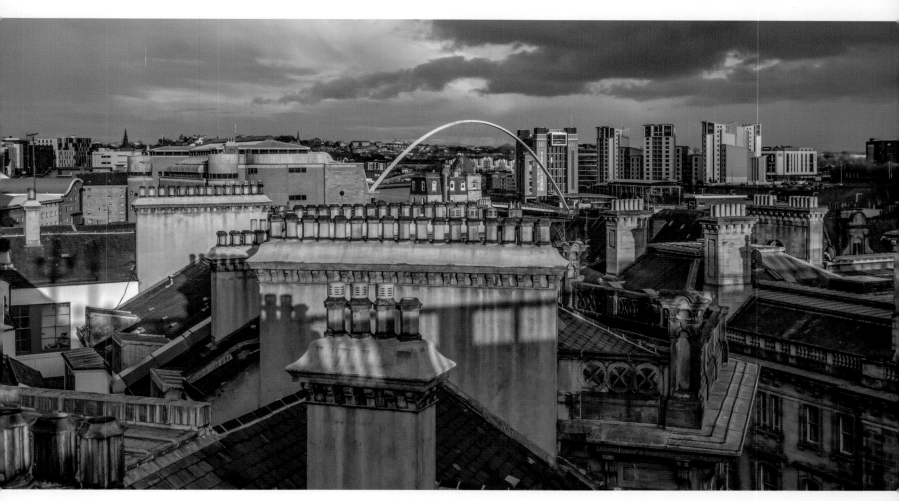

Chimney pots, Newcastle

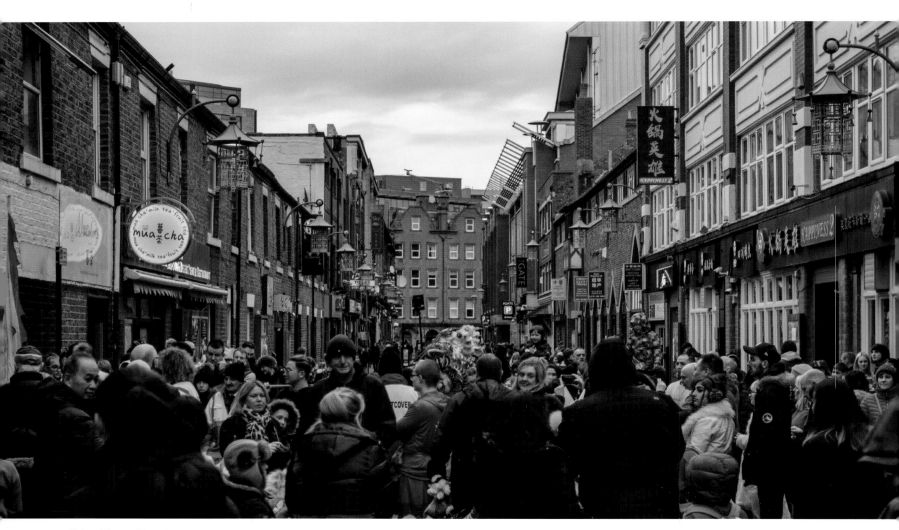

China Town, New Year 2020

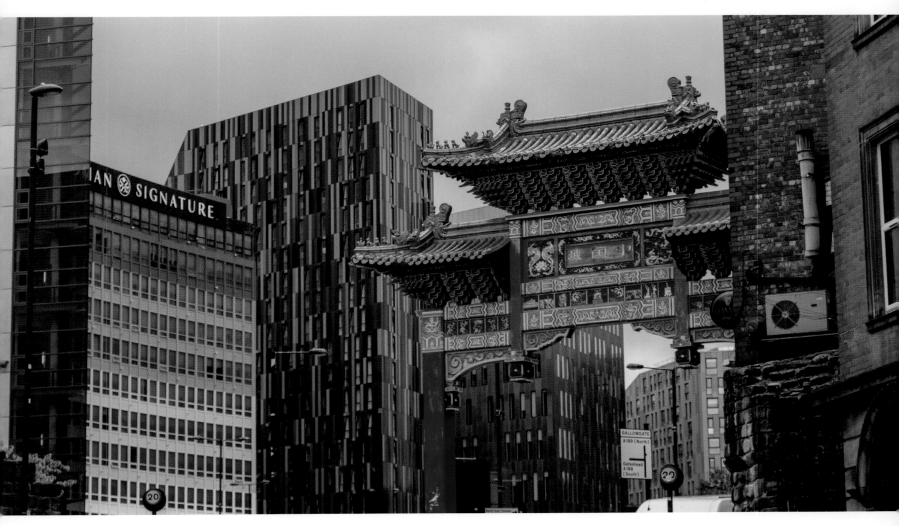

Chinatown Arch

Christmas market,
Northumberland Street

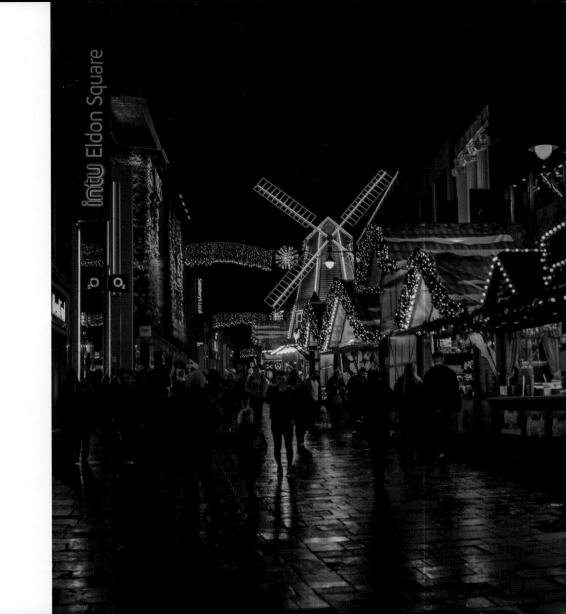

Christmas market

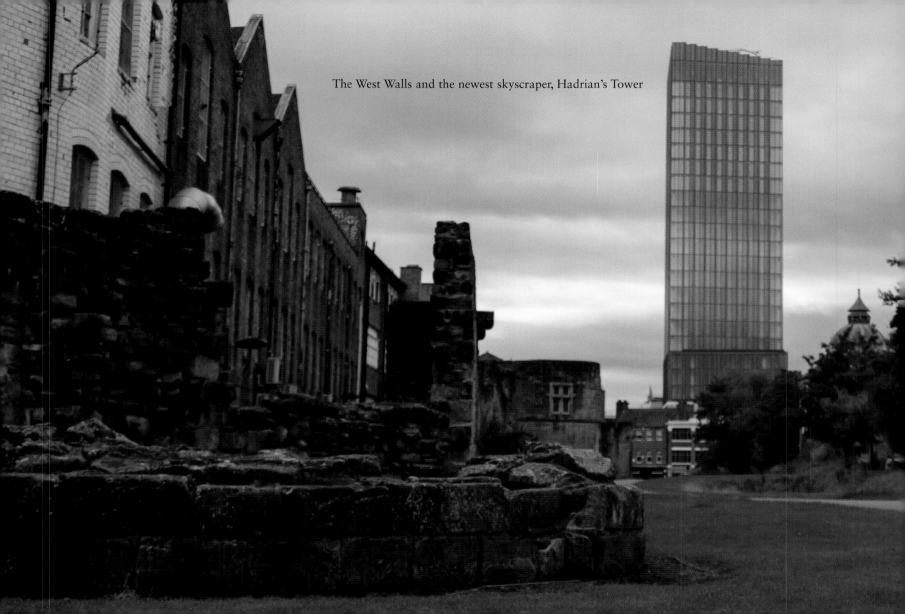

The West Walls and the newest skyscraper, Hadrian's Tower

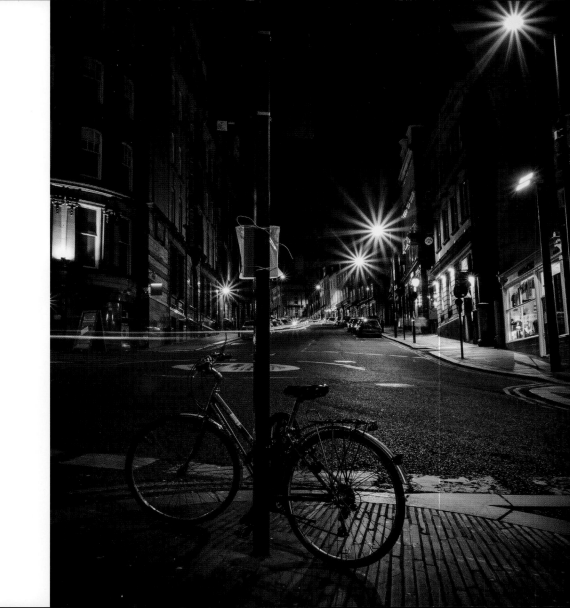

Dean Street at night

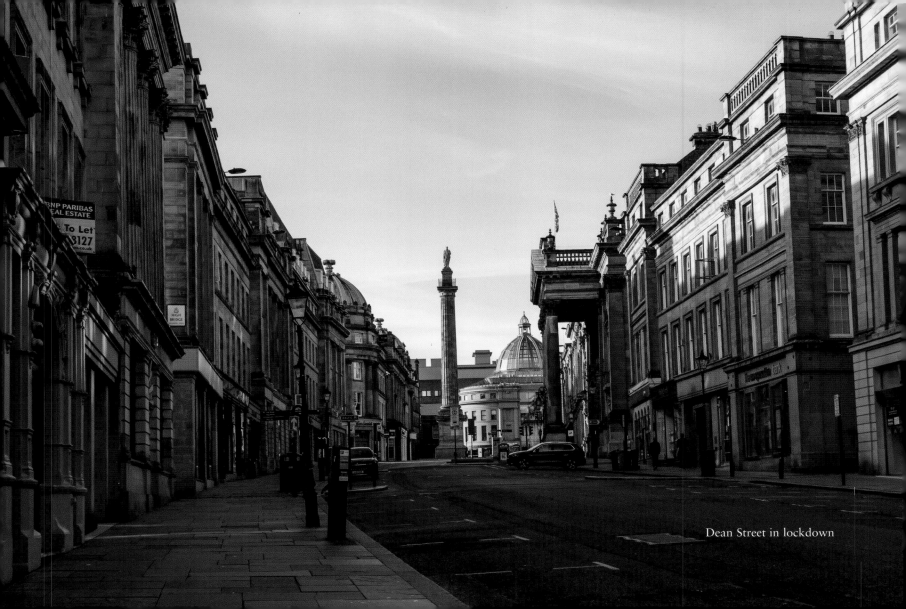

Dean Street in lockdown

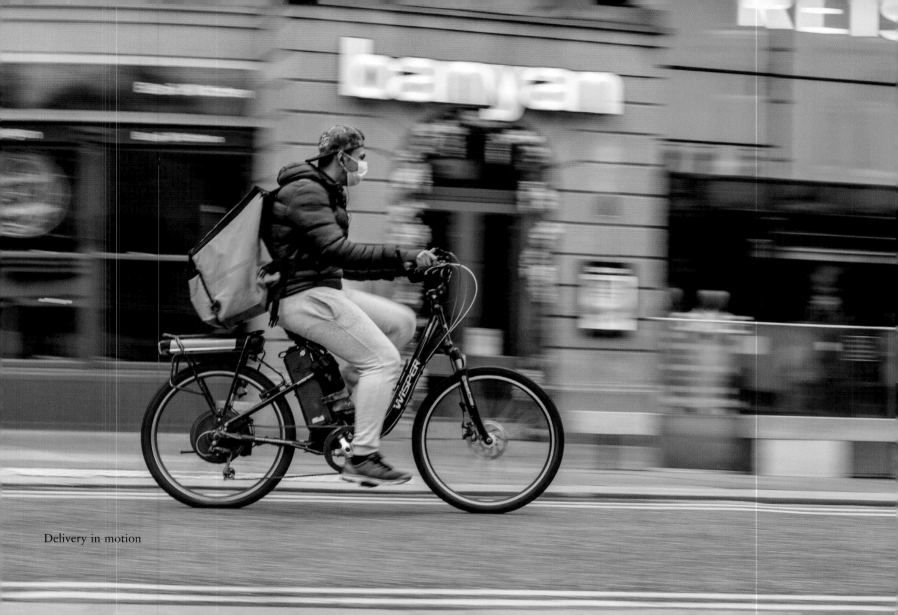

Delivery in motion

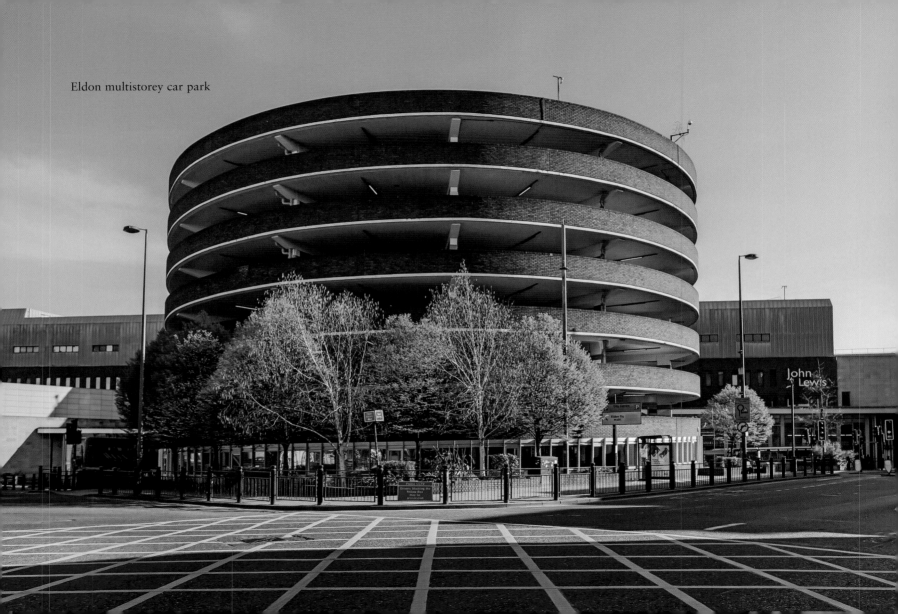
Eldon multistorey car park

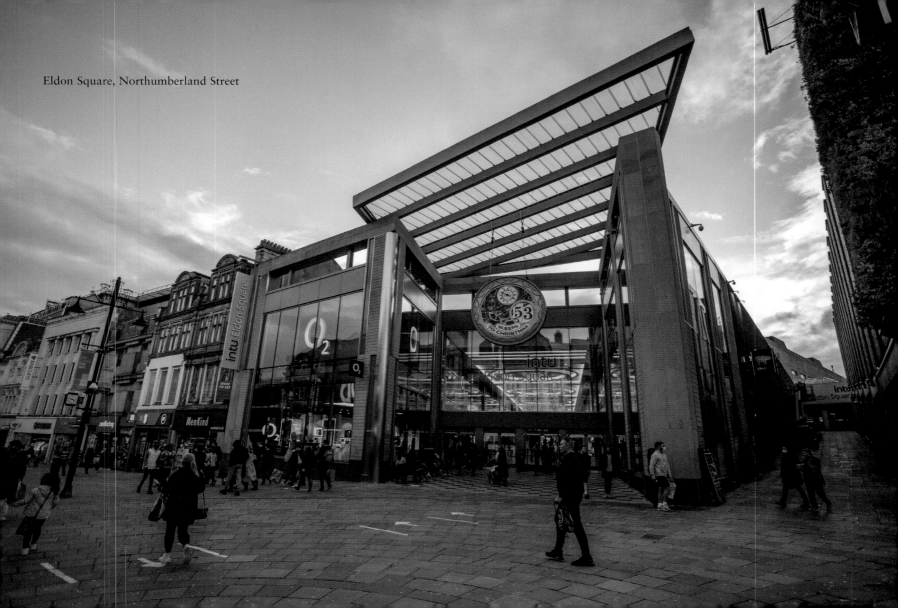

Eldon Square, Northumberland Street

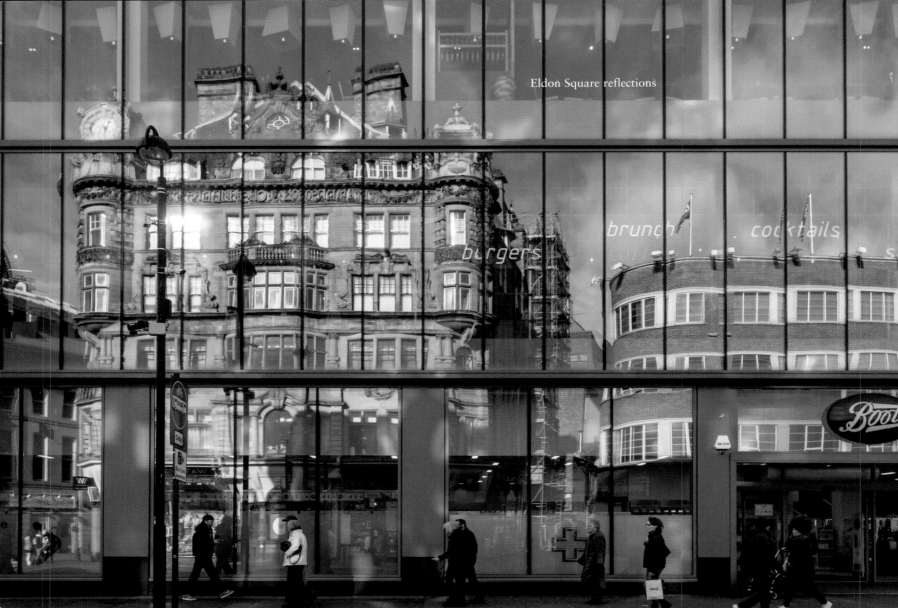

Eldon Square reflections

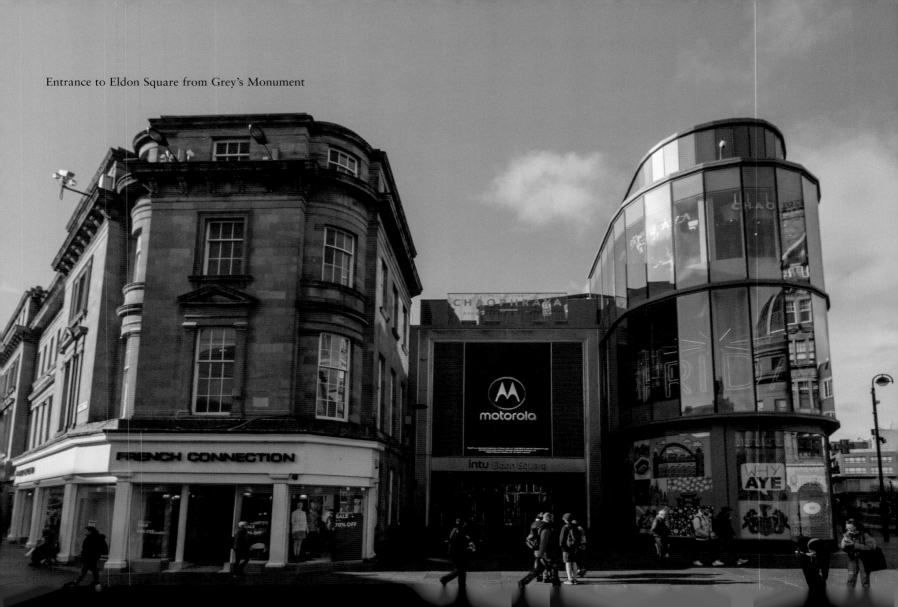

Entrance to Eldon Square from Grey's Monument

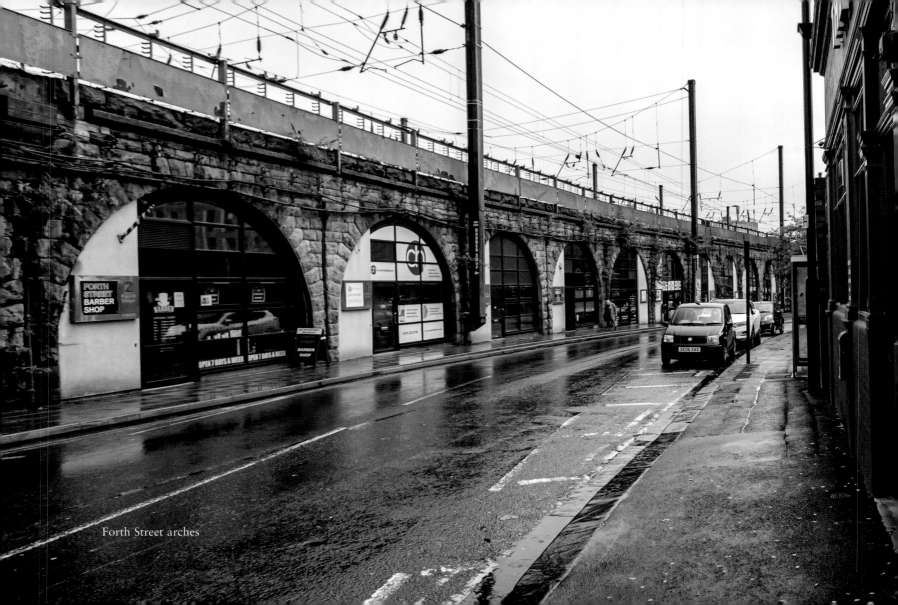
Forth Street arches

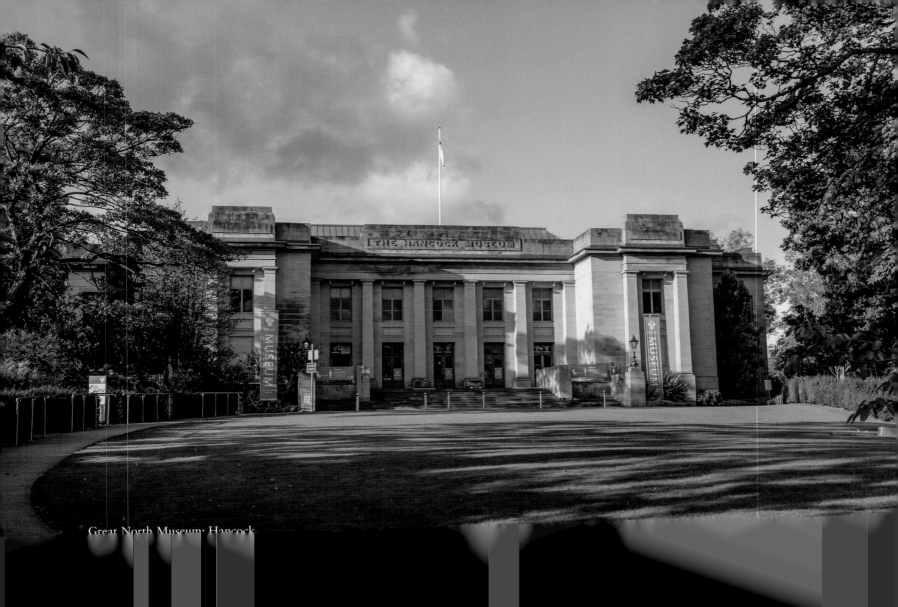

THE HANCOCK MUSEUM

Great North Museum: Hancock

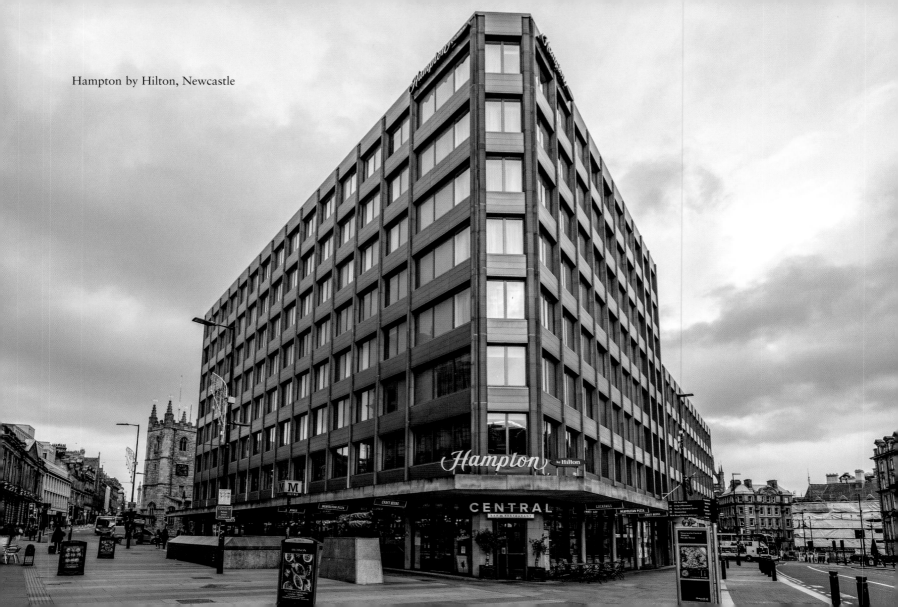

Hampton by Hilton, Newcastle

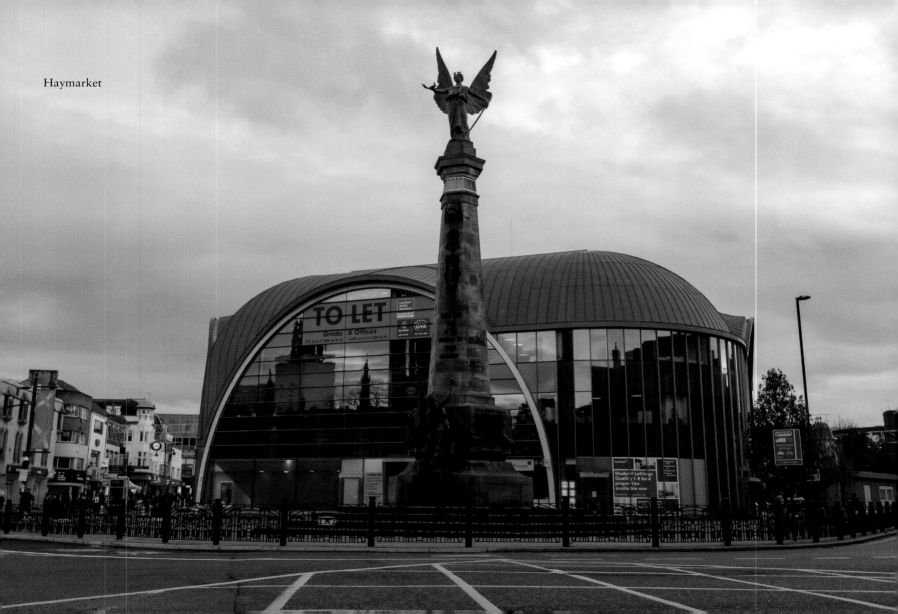

Haymarket

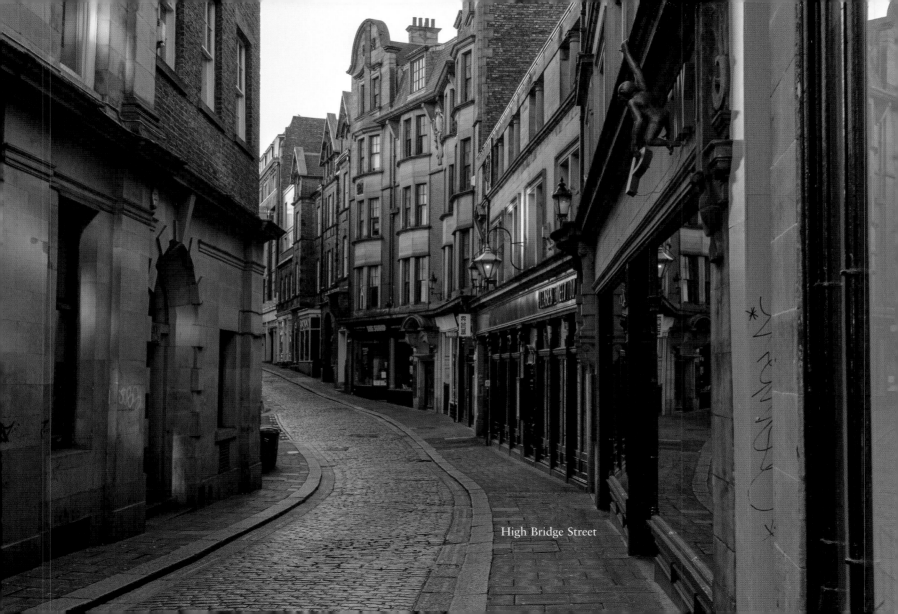

High Bridge Street

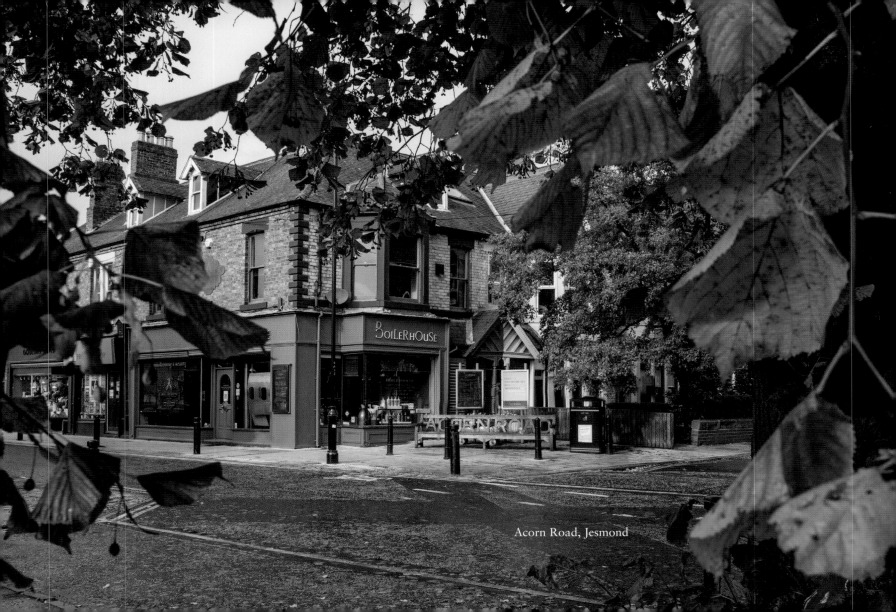

Acorn Road, Jesmond

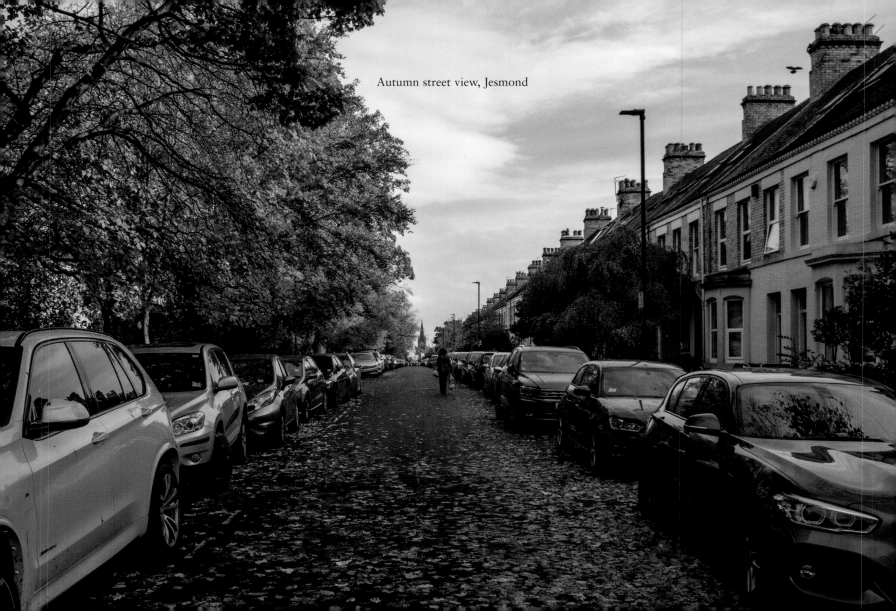
Autumn street view, Jesmond

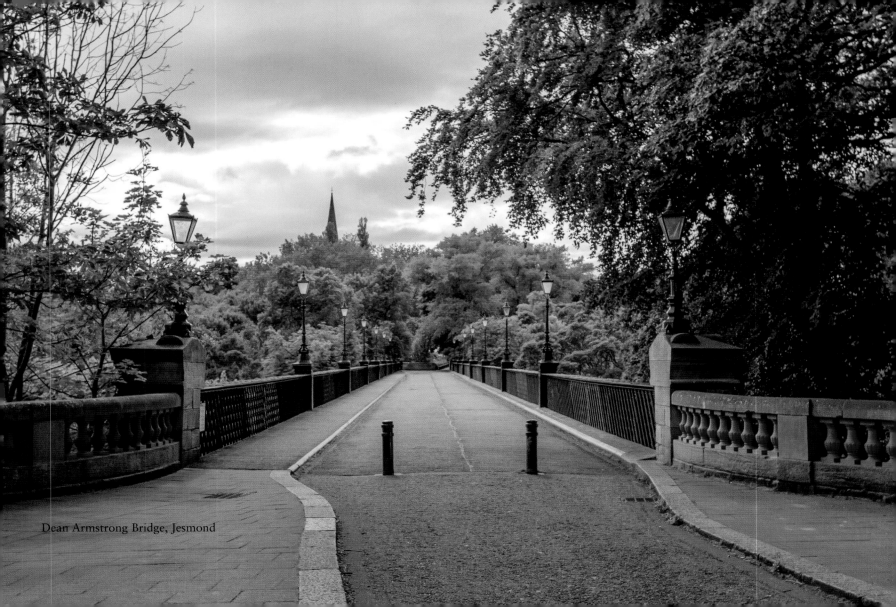
Dean Armstrong Bridge, Jesmond

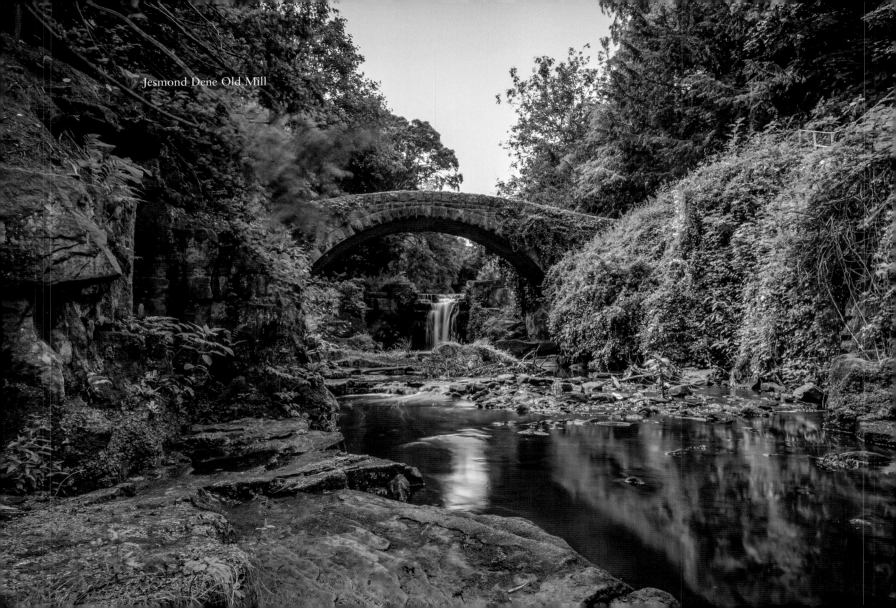
Jesmond Dene Old Mill

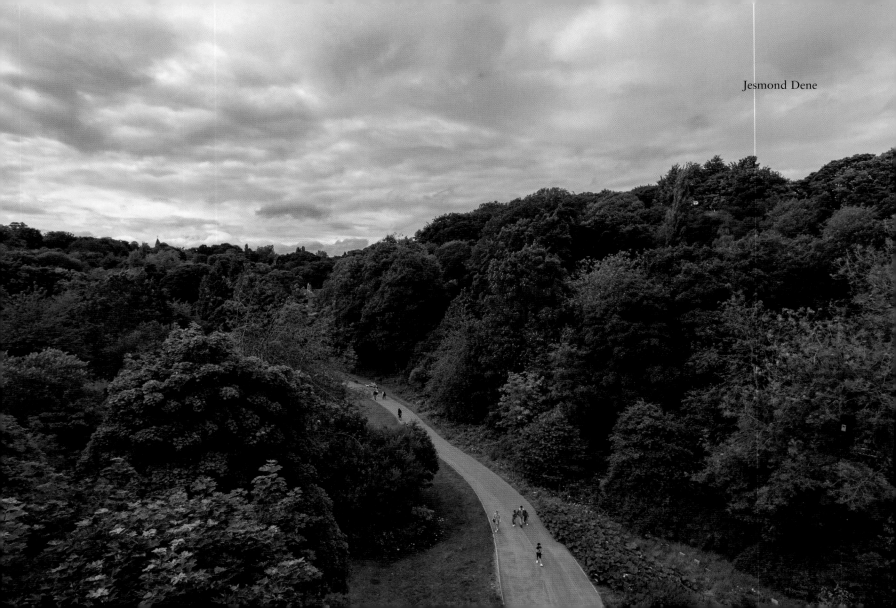

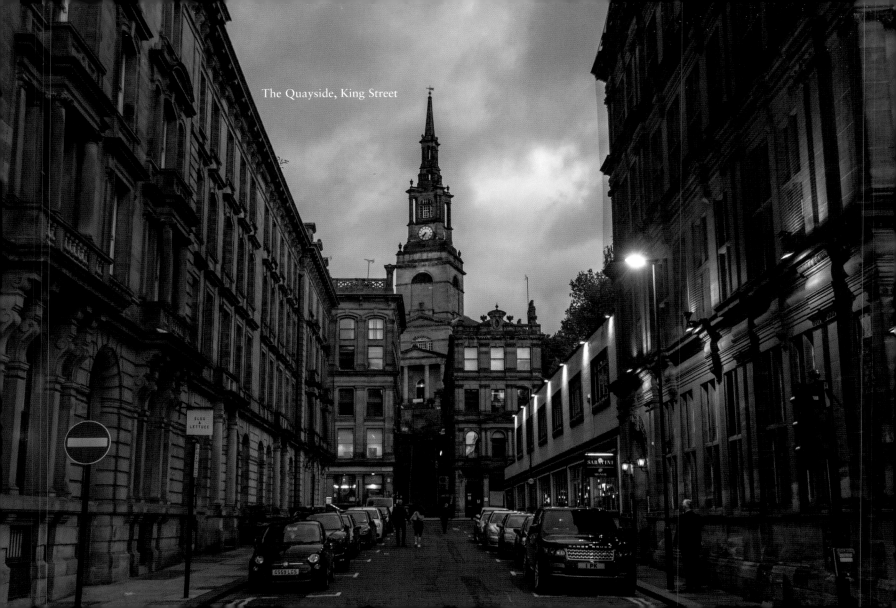

The Quayside, King Street

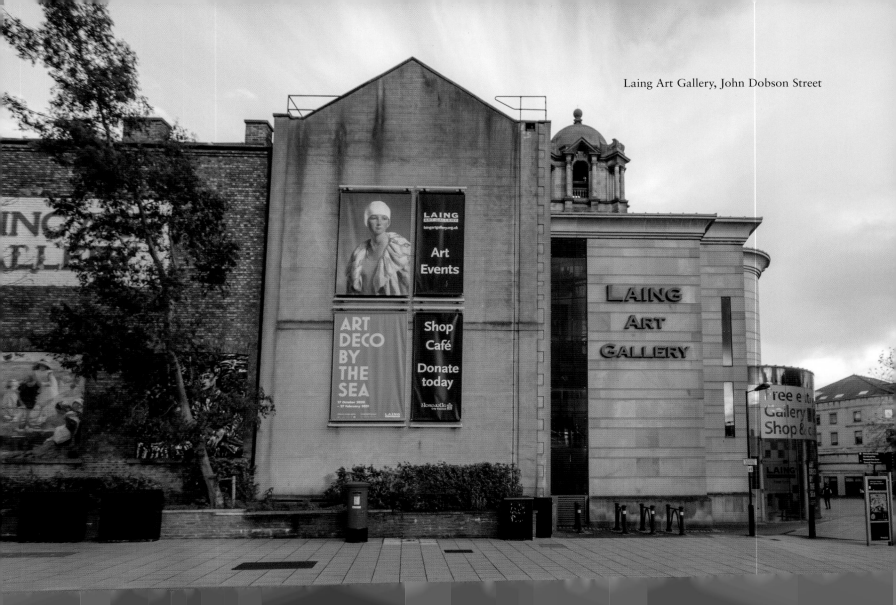

Laing Art Gallery, John Dobson Street

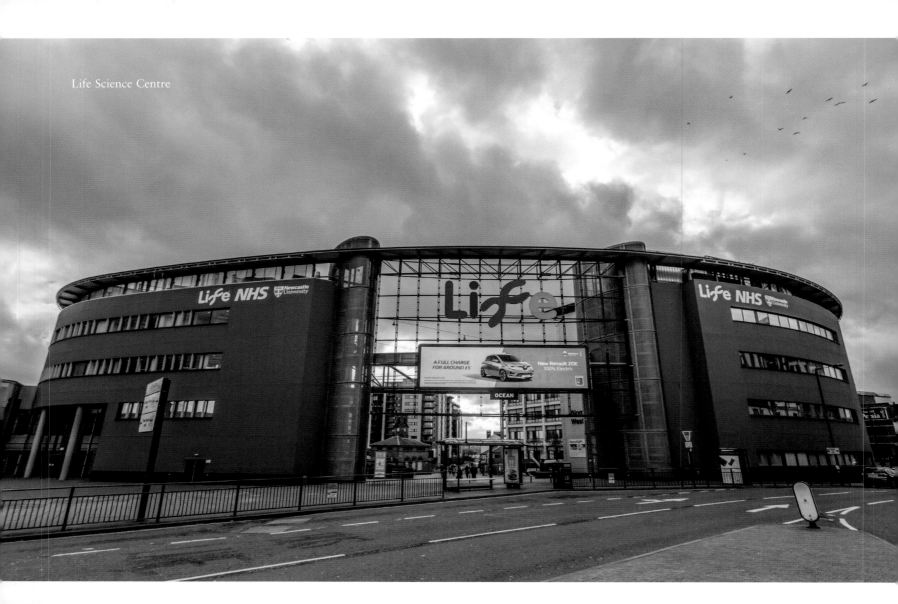

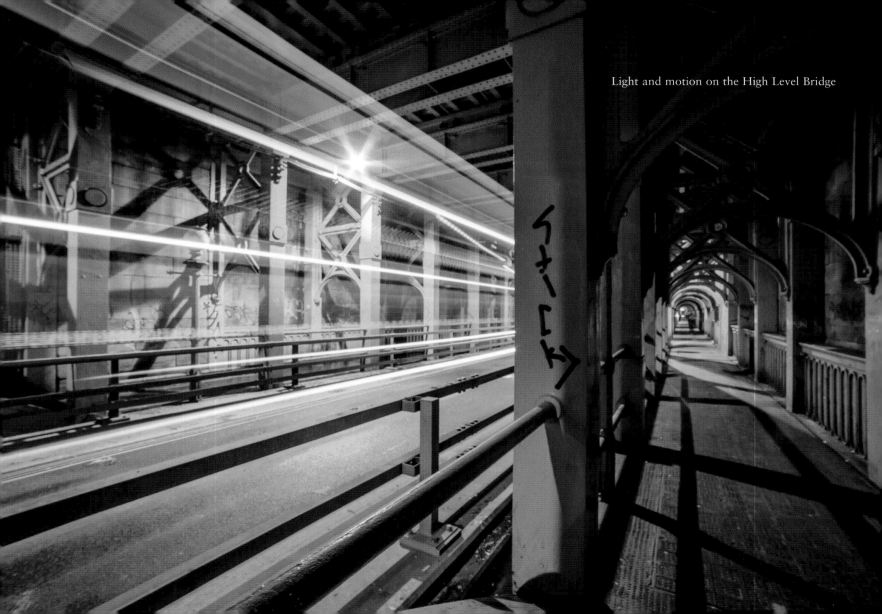

Light and motion on the High Level Bridge

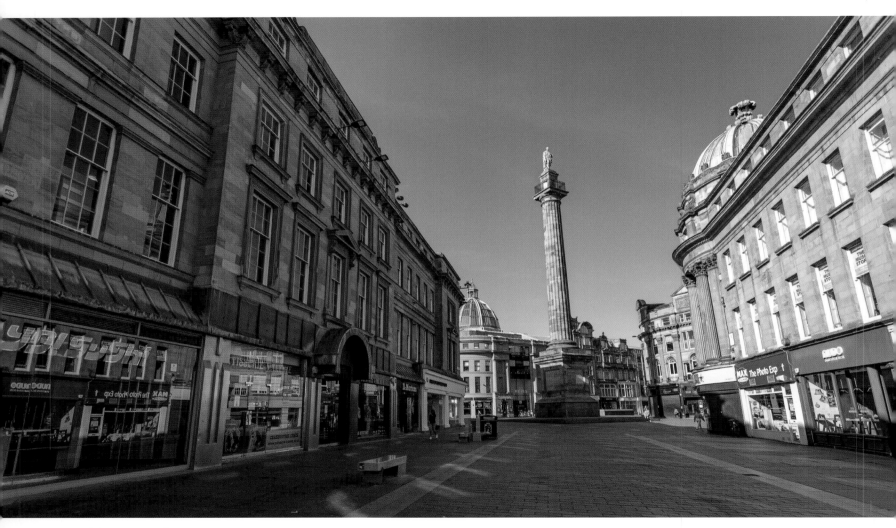

Lockdown view of Grey's Monument

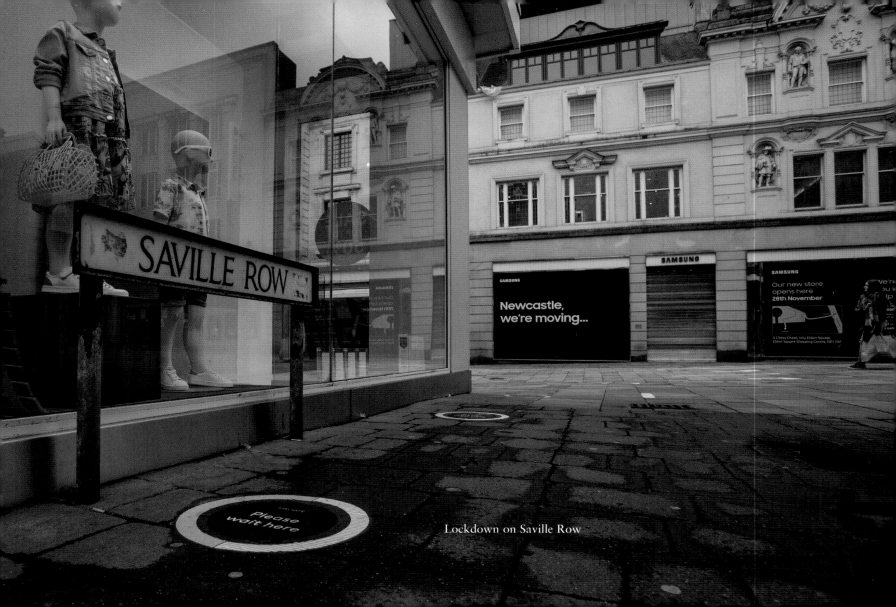

Lockdown on Saville Row

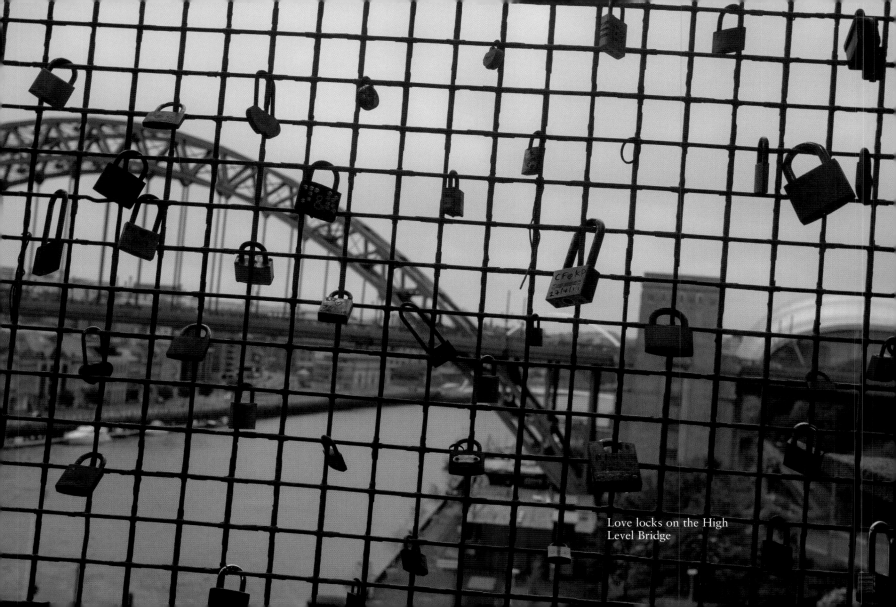

Love locks on the High
Level Bridge

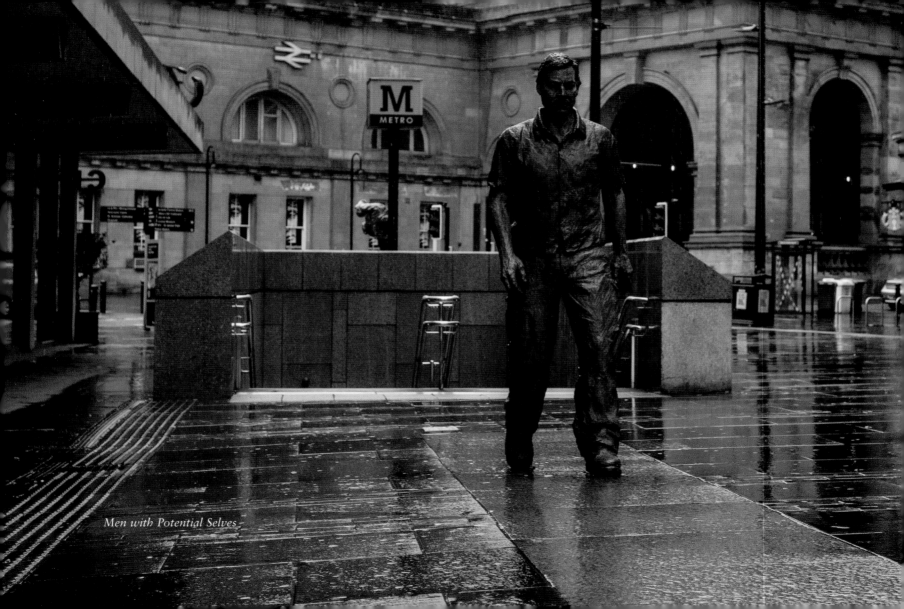

Men with Potential Selves

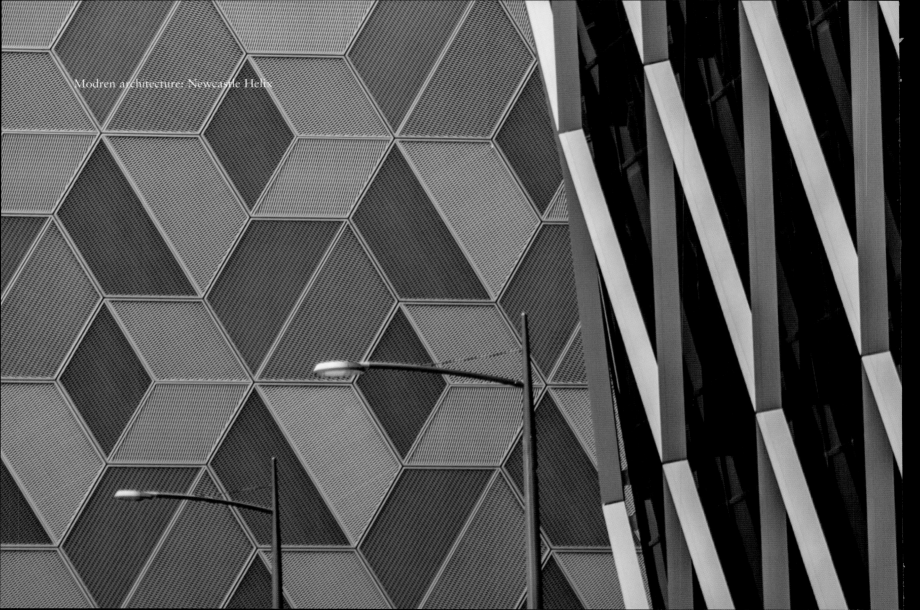

Modren architecture: Newcastle Helix

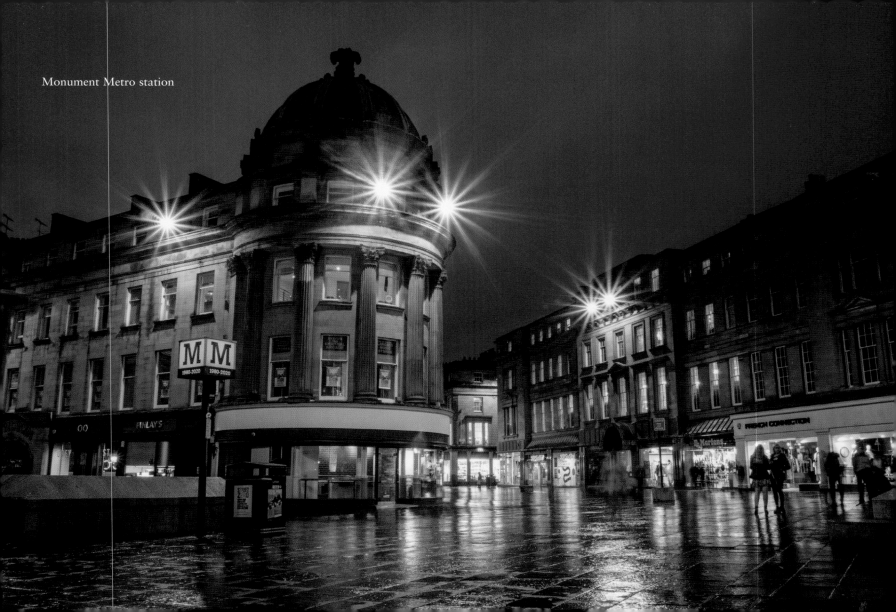

Monument Metro station

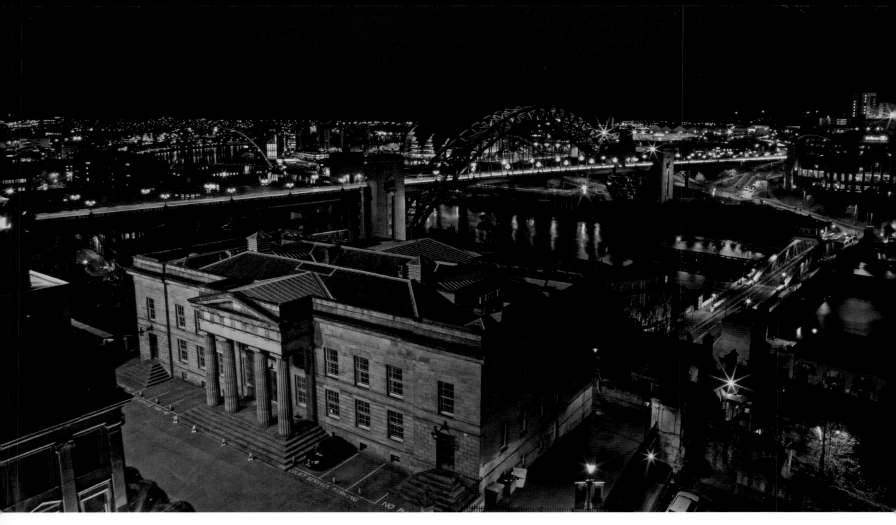

Moot Hall, Newcastle

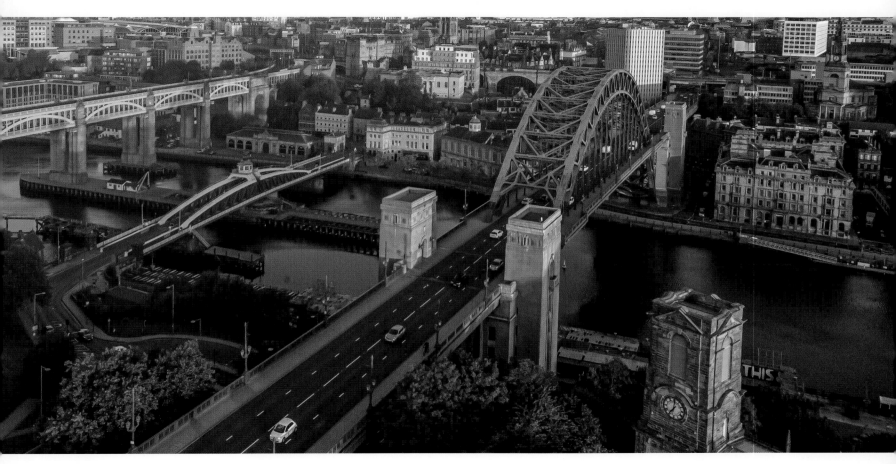

Newcastle bridges

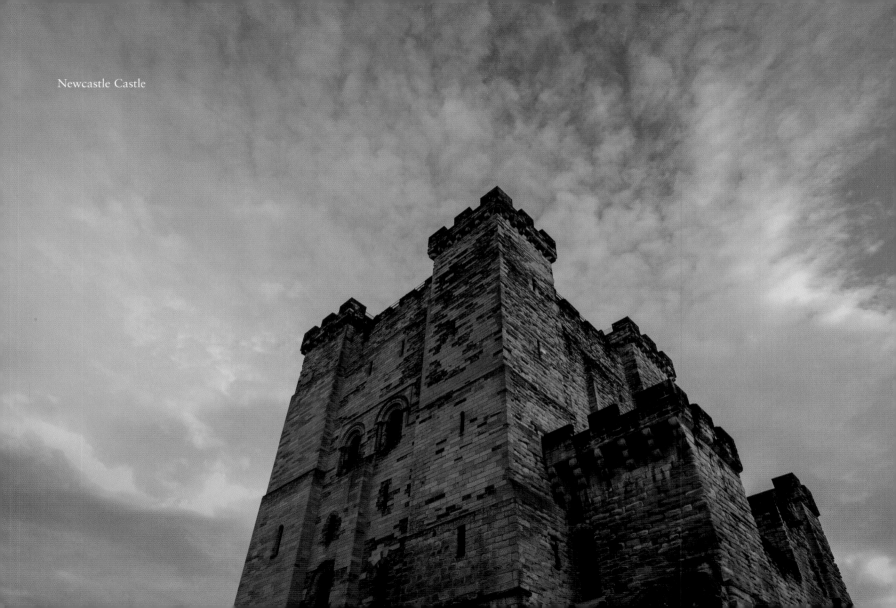

Newcastle Castle

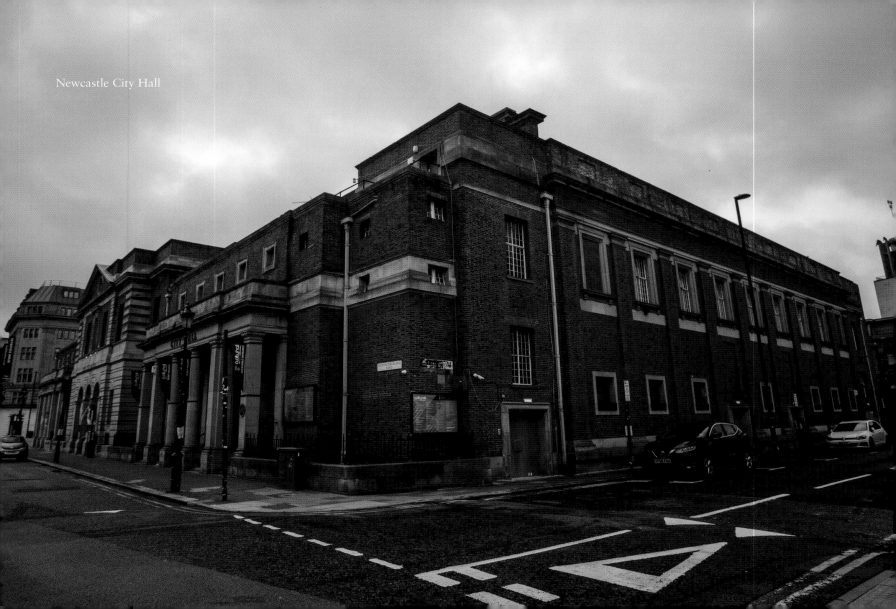

Newcastle City Hall

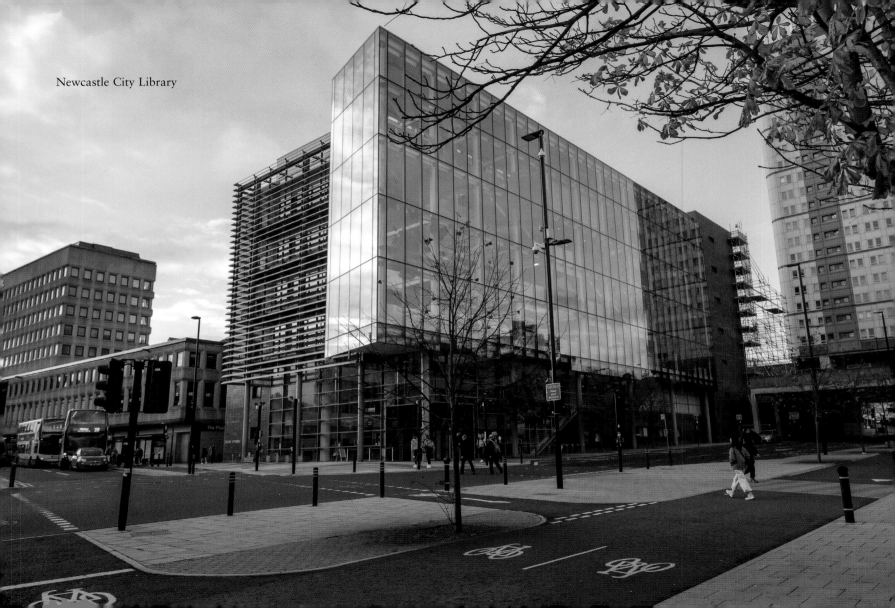
Newcastle City Library

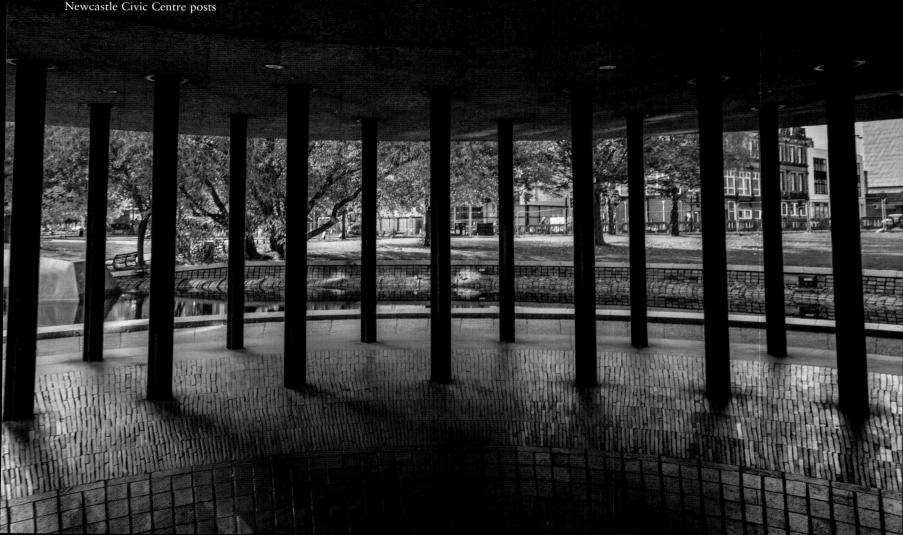
Newcastle Civic Centre posts

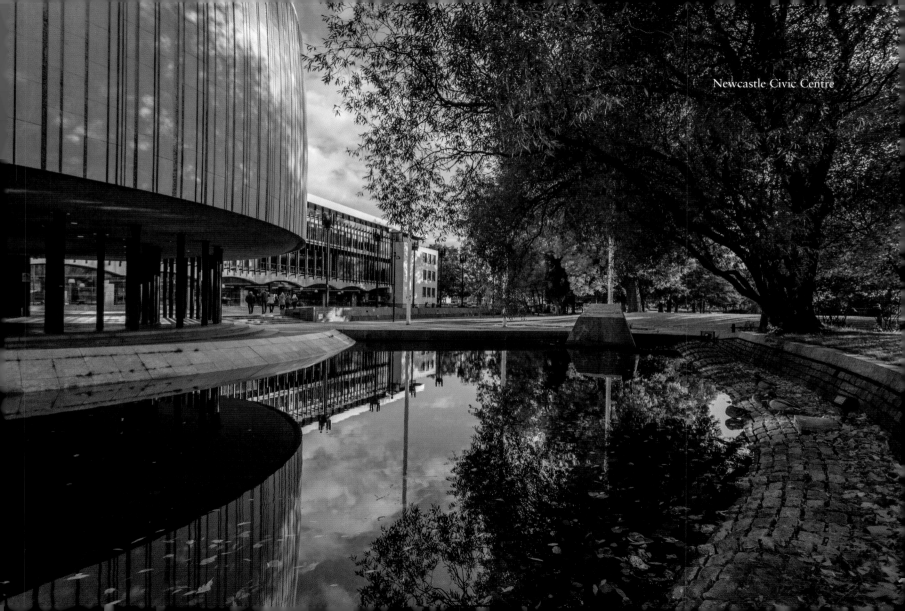

Newcastle Civic Centre

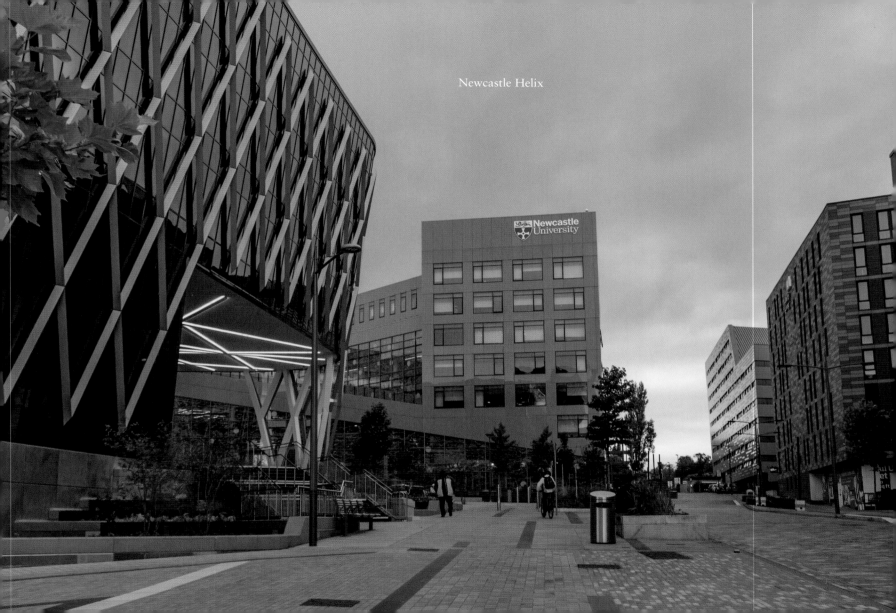

Newcastle Helix

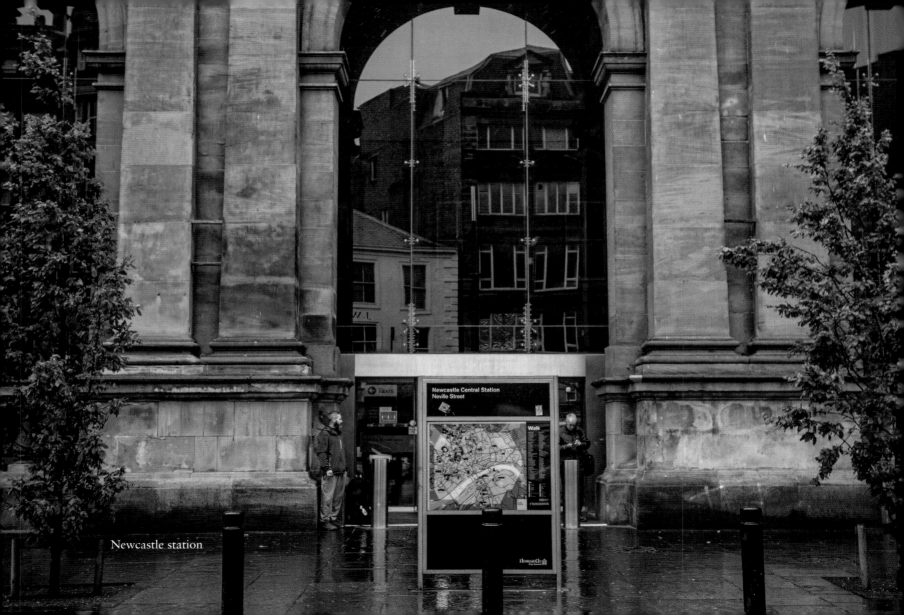

Newcastle station

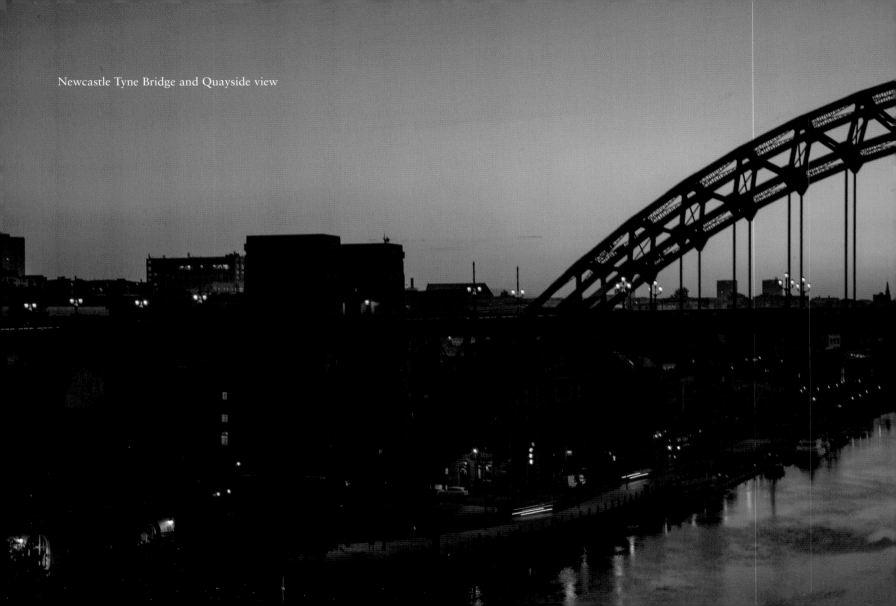

Newcastle Tyne Bridge and Quayside view

Night life, Eldon Square

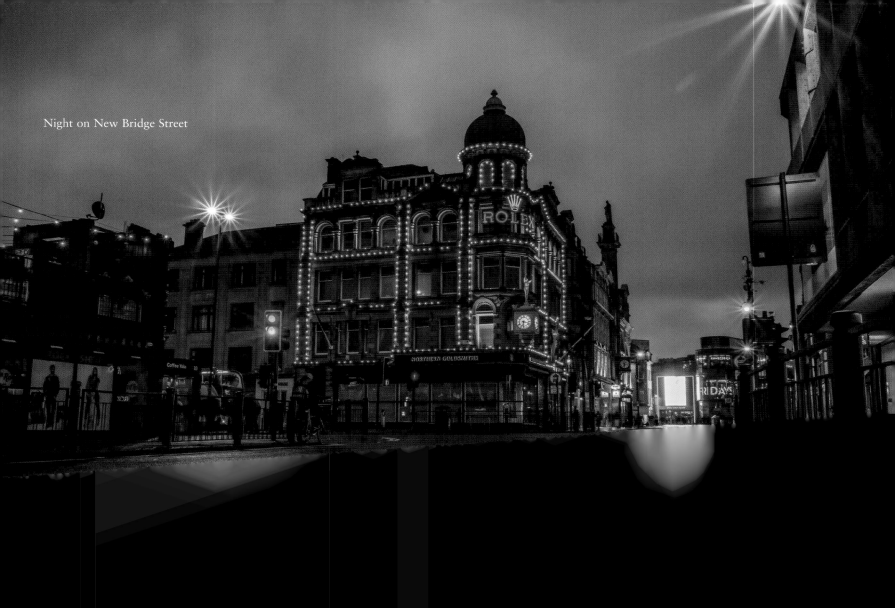

Night on New Bridge Street

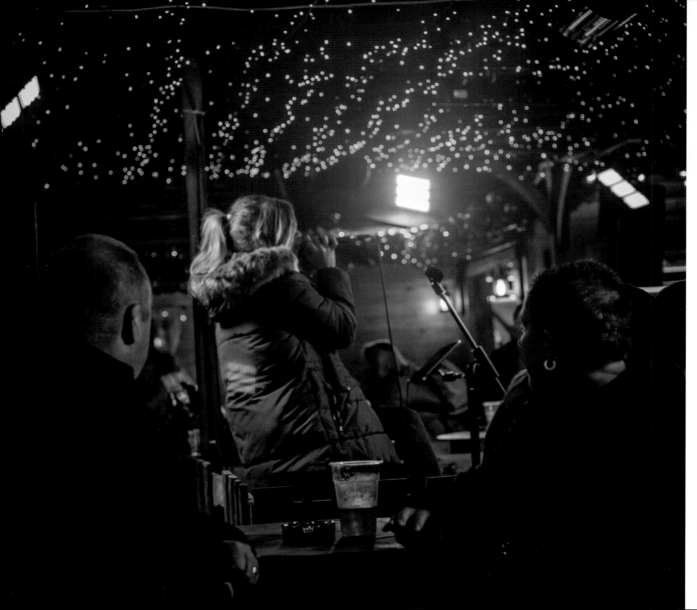

Night life in Newcastle

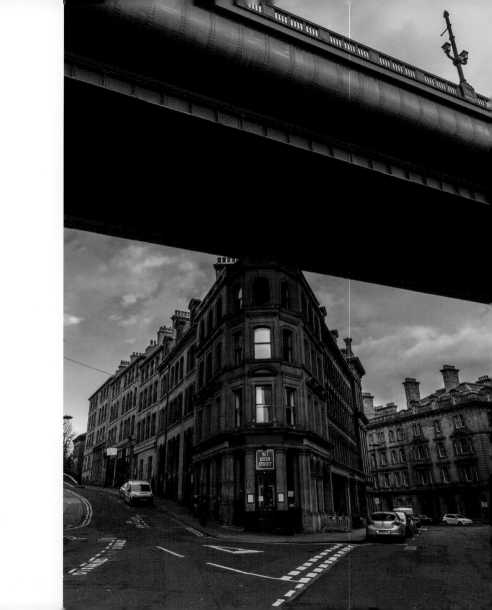

No. 1 Queen Street under the Tyne Bridge

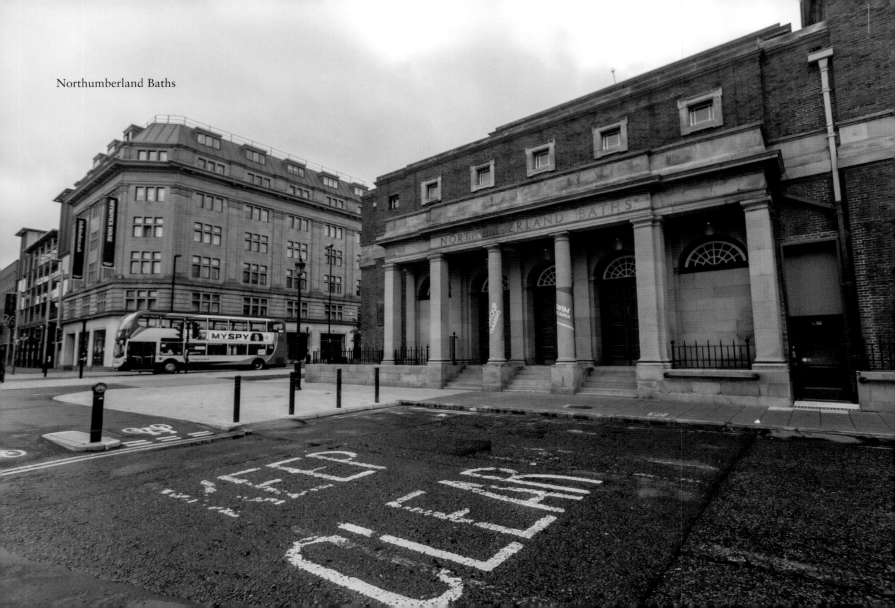

Northumberland Baths

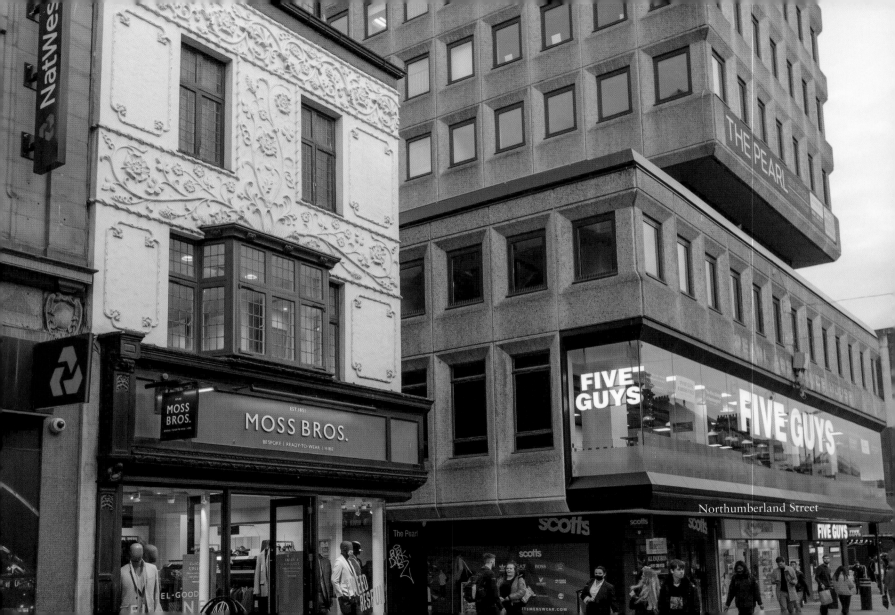

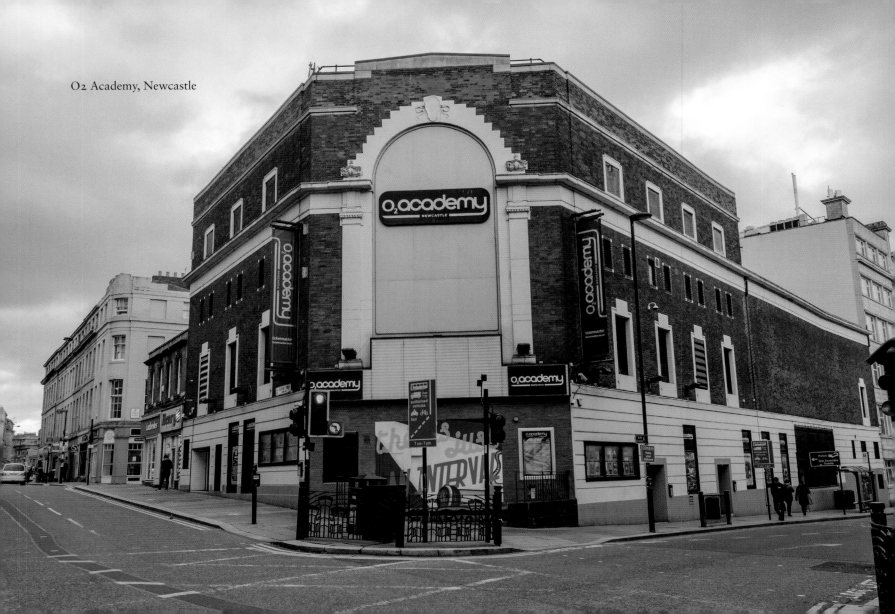

O2 Academy, Newcastle

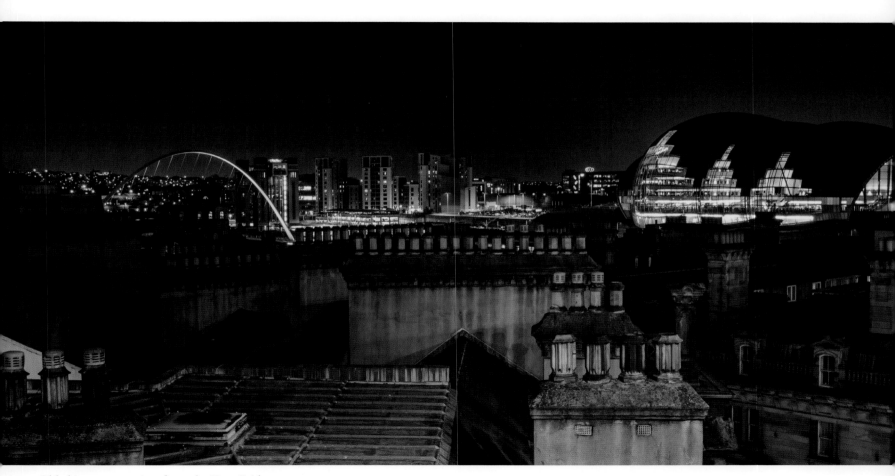

Old chimney pots view from the Tyne Bridge

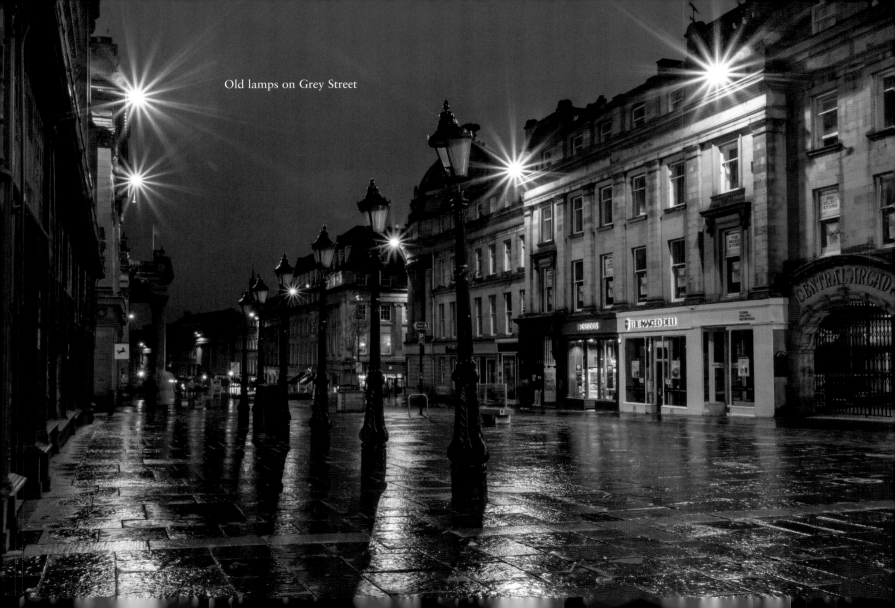
Old lamps on Grey Street

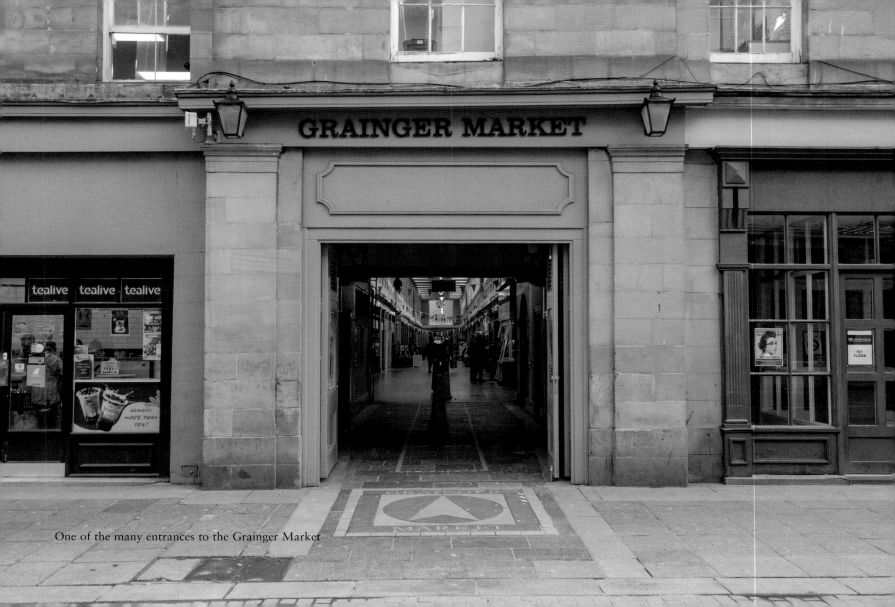

One of the many entrances to the Grainger Market

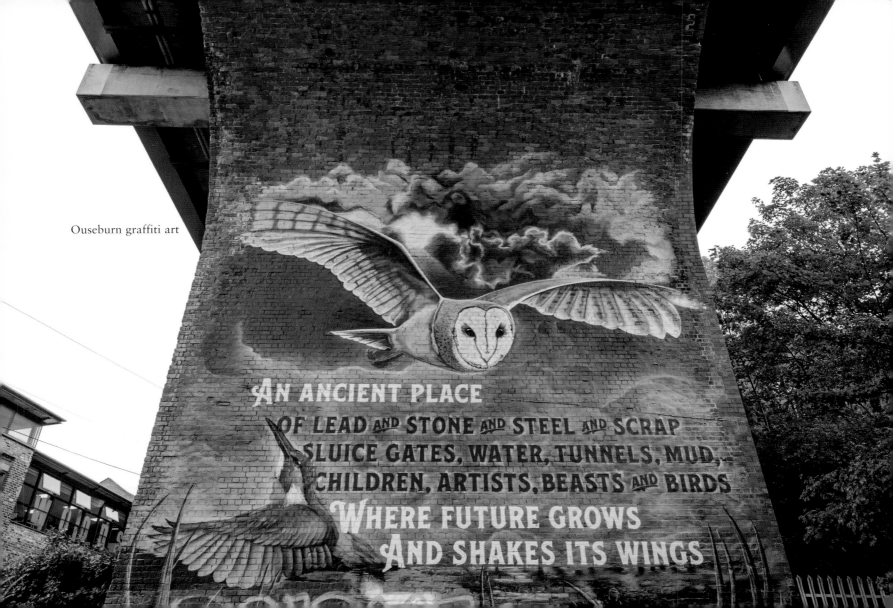

Ouseburn graffiti art

AN ANCIENT PLACE
OF LEAD AND STONE AND STEEL AND SCRAP
SLUICE GATES, WATER, TUNNELS, MUD,
CHILDREN, ARTISTS, BEASTS AND BIRDS
WHERE FUTURE GROWS
AND SHAKES ITS WINGS

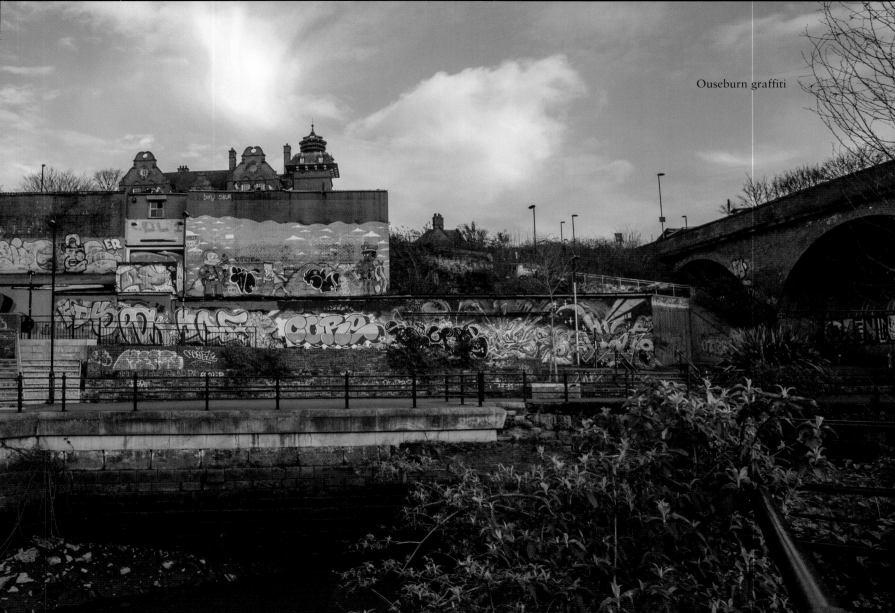

Ouseburn graffiti

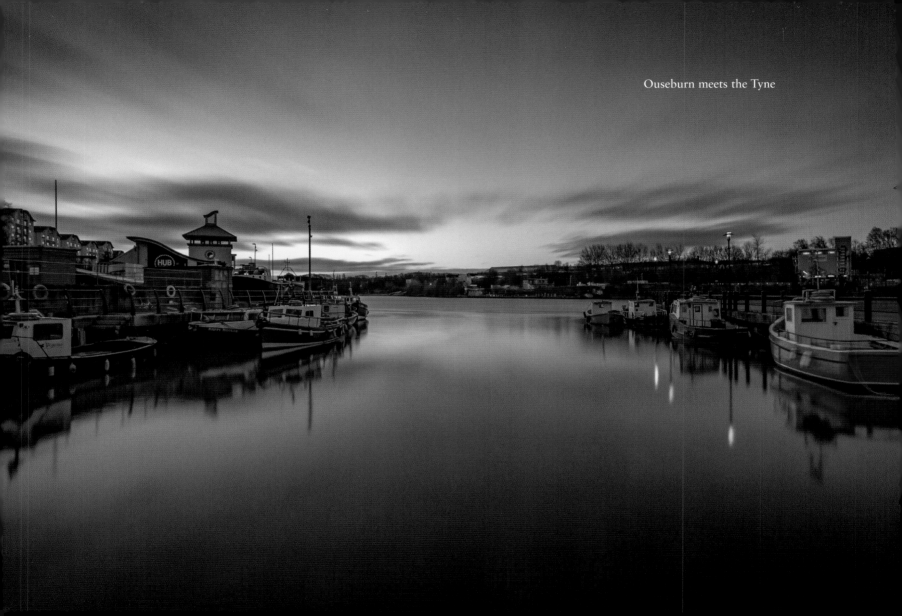

Ouseburn meets the Tyne

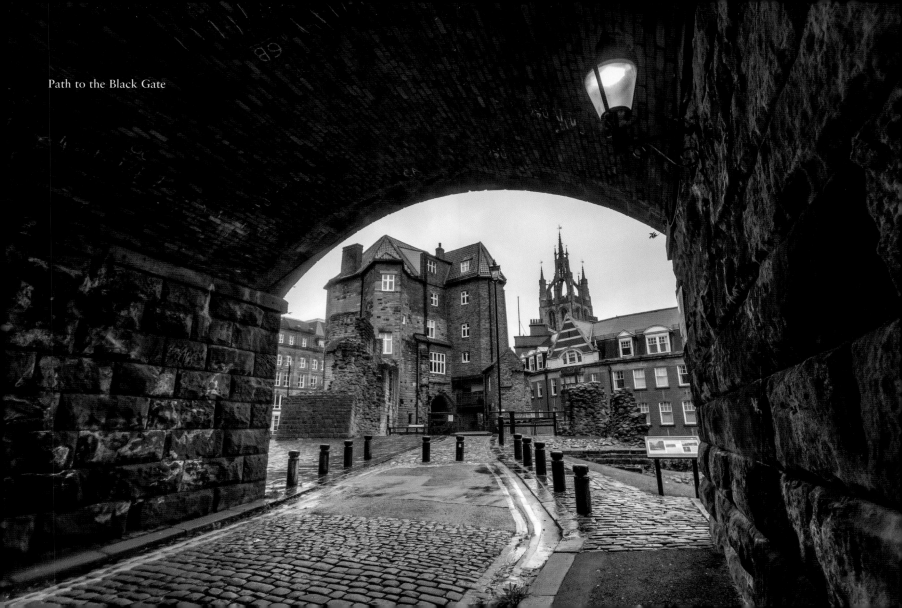

Path to the Black Gate

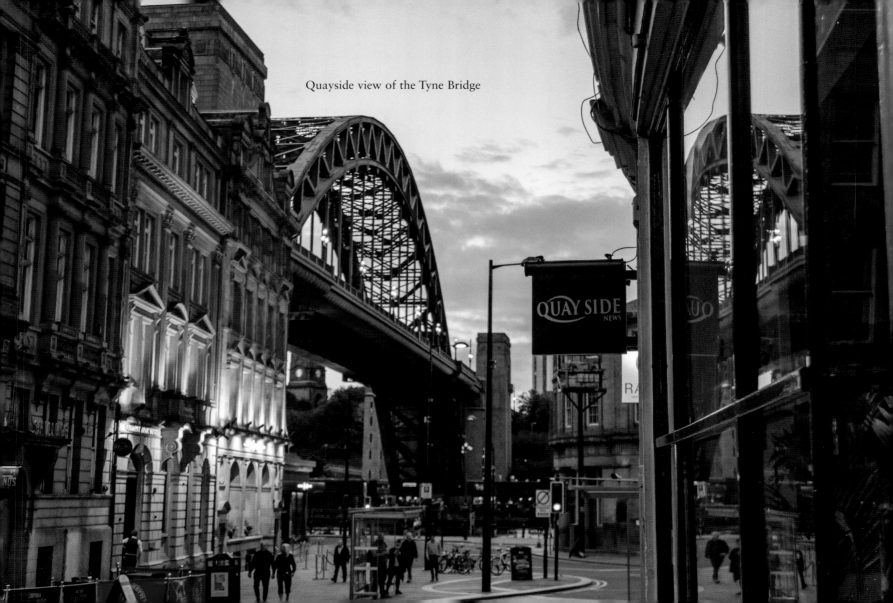

Quayside view of the Tyne Bridge

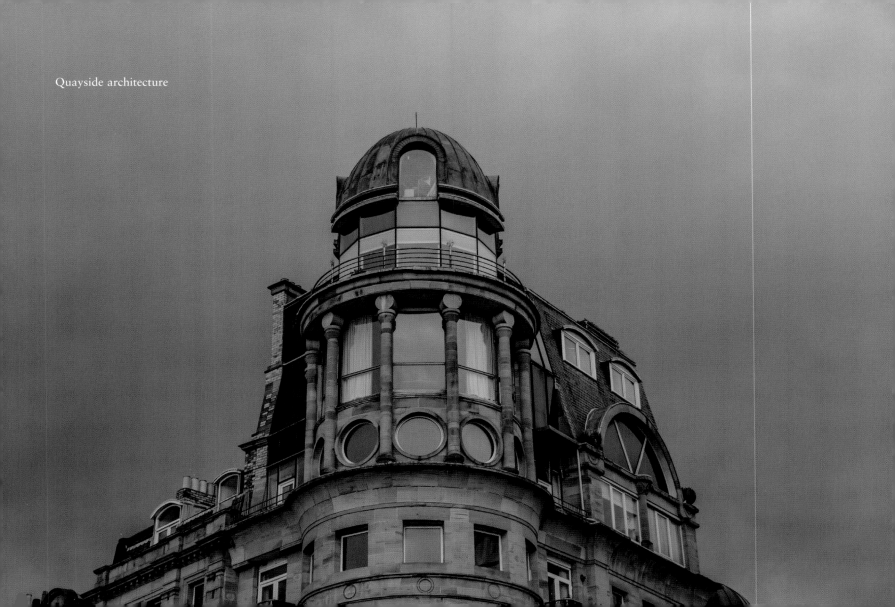

Quayside architecture

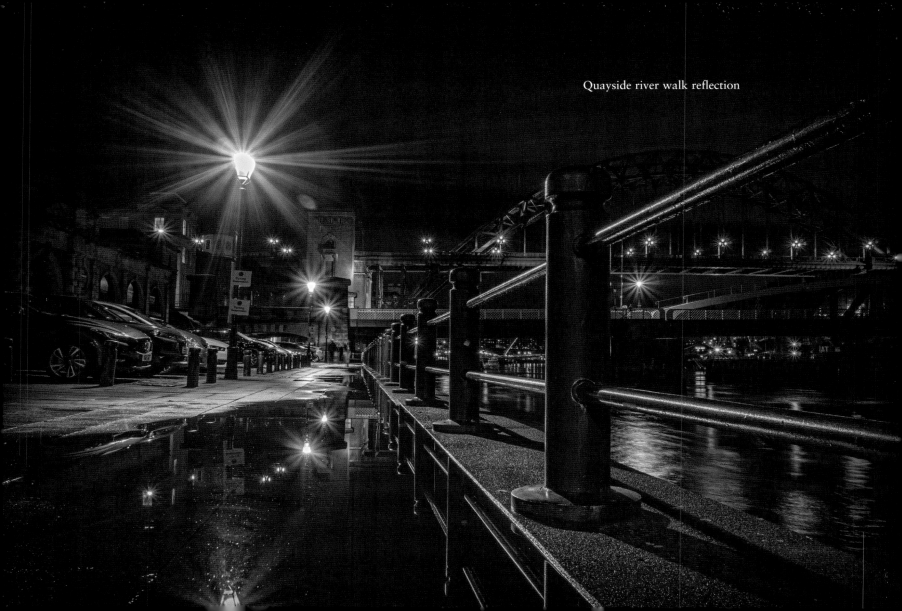
Quayside river walk reflection

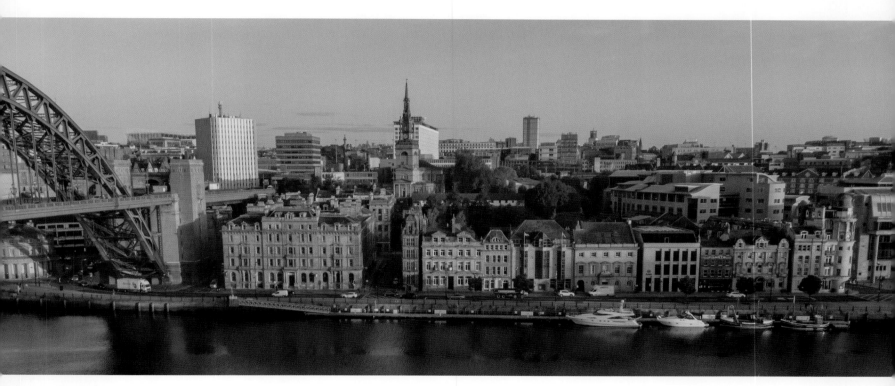

Quayside river view

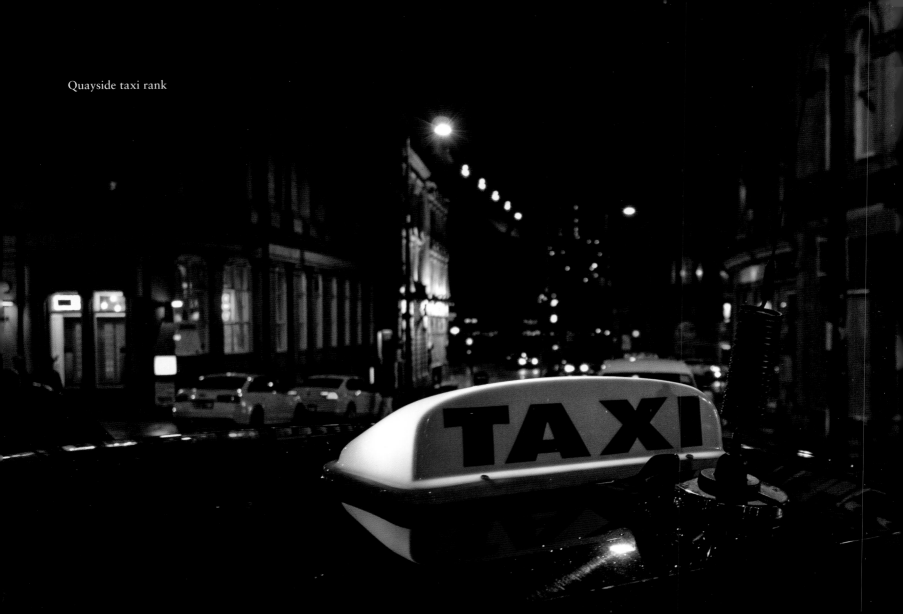
Quayside taxi rank

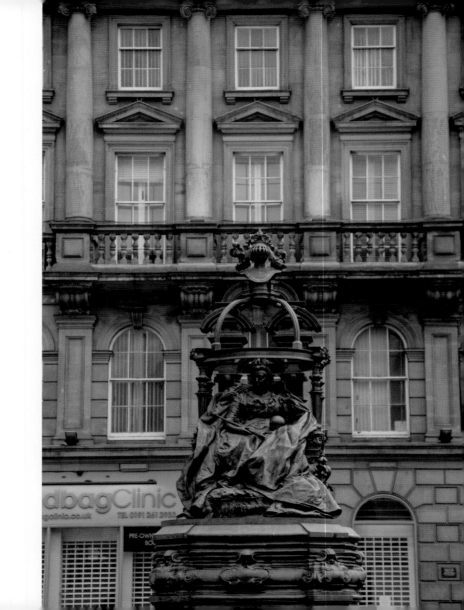

Queen Victoria statue, Newcastle

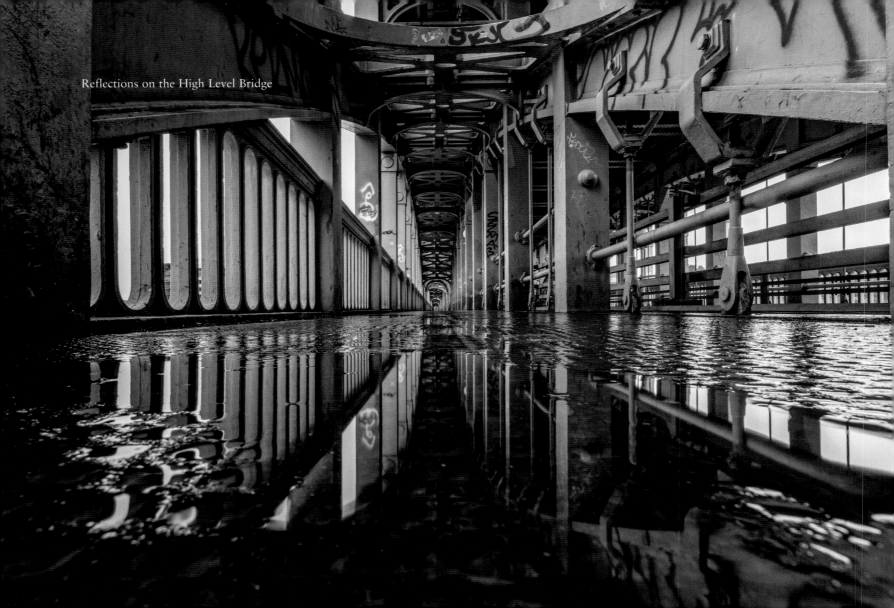

Reflections on the High Level Bridge

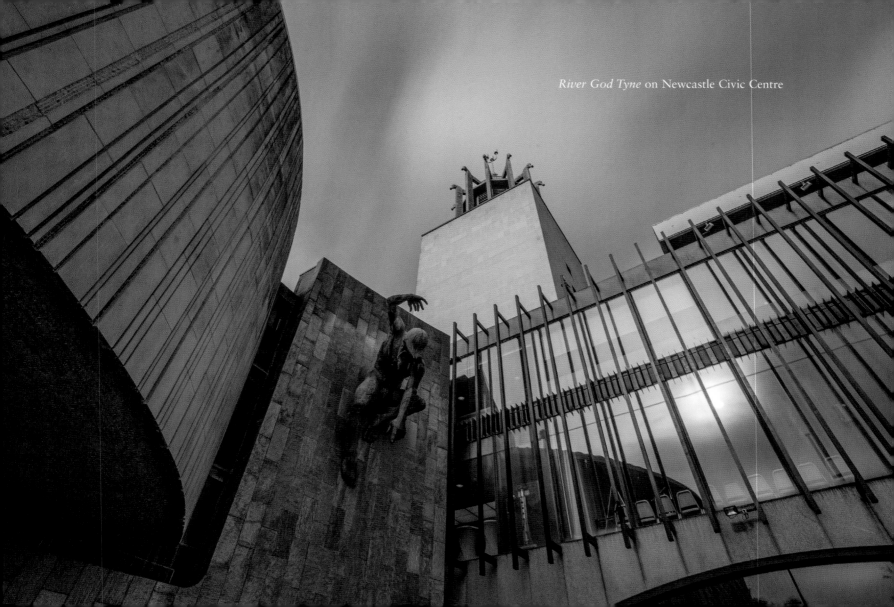

River God Tyne on Newcastle Civic Centre

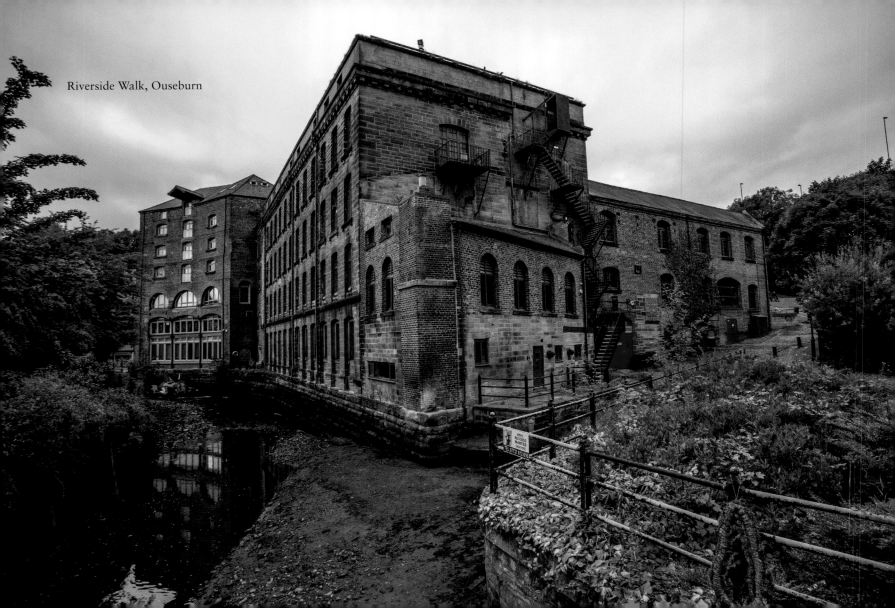

Riverside Walk, Ouseburn

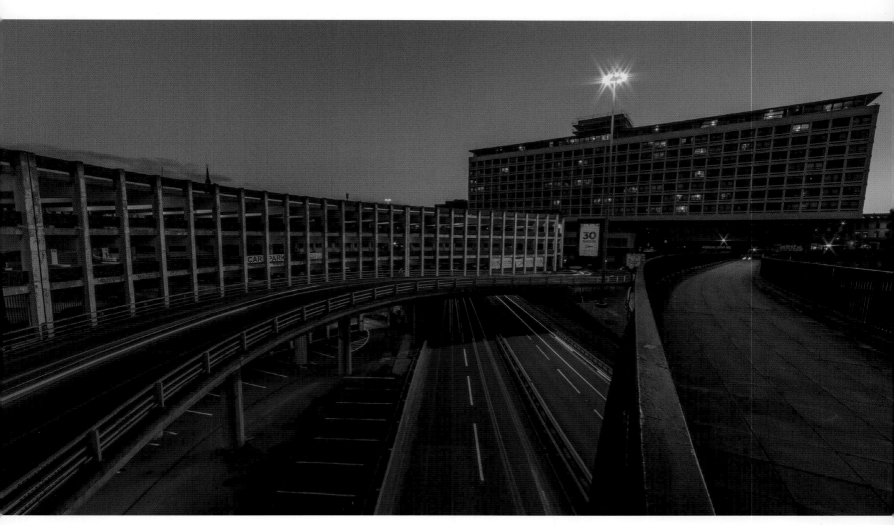

Road view of 55 Degrees North

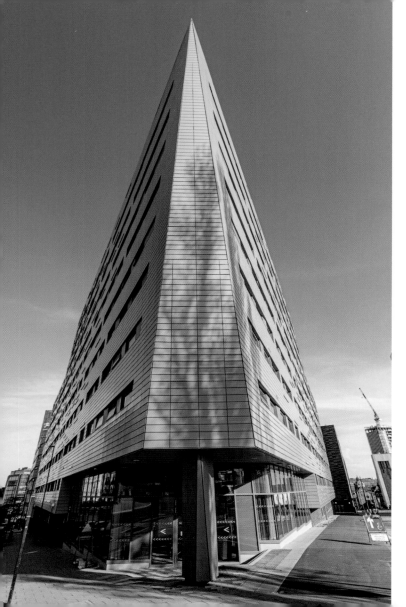

Science Central Point

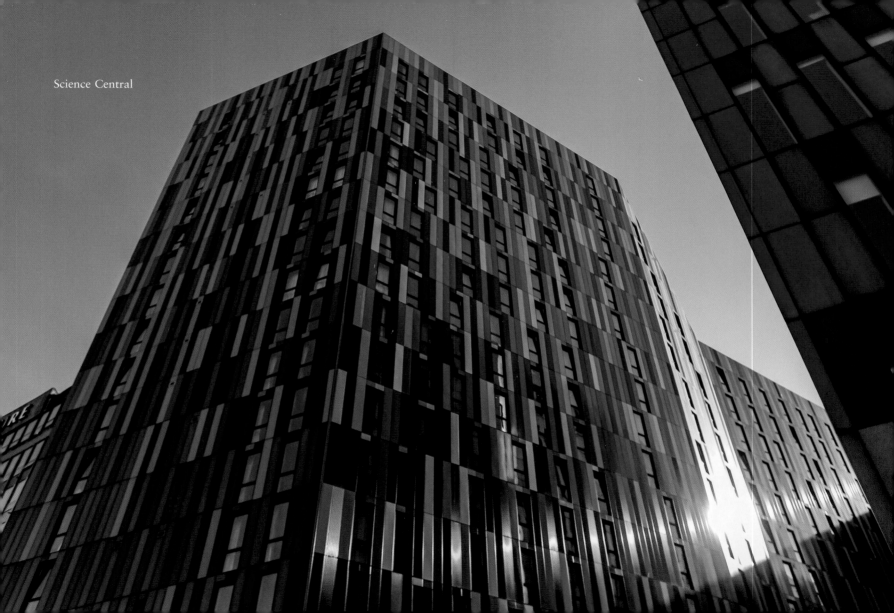

Science Central

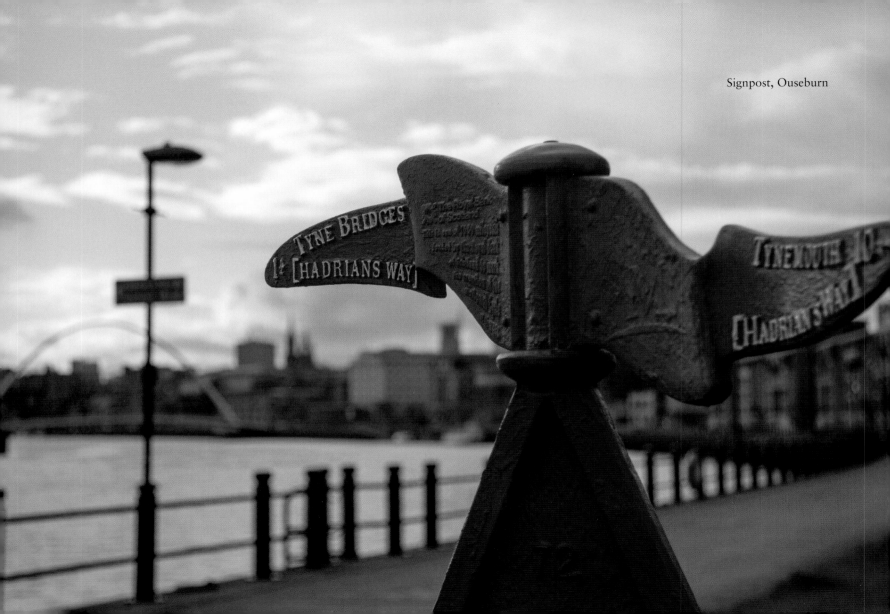

Signpost, Ouseburn

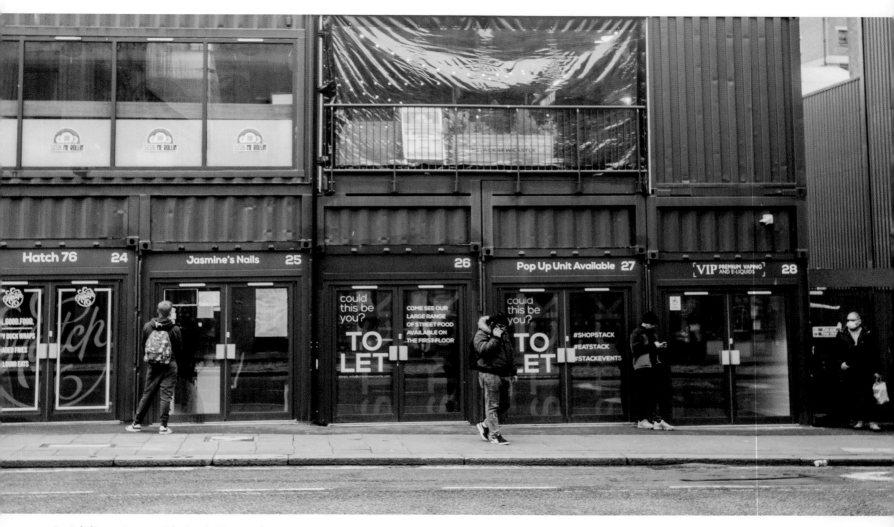

Social distancing outside Stack Newcastle

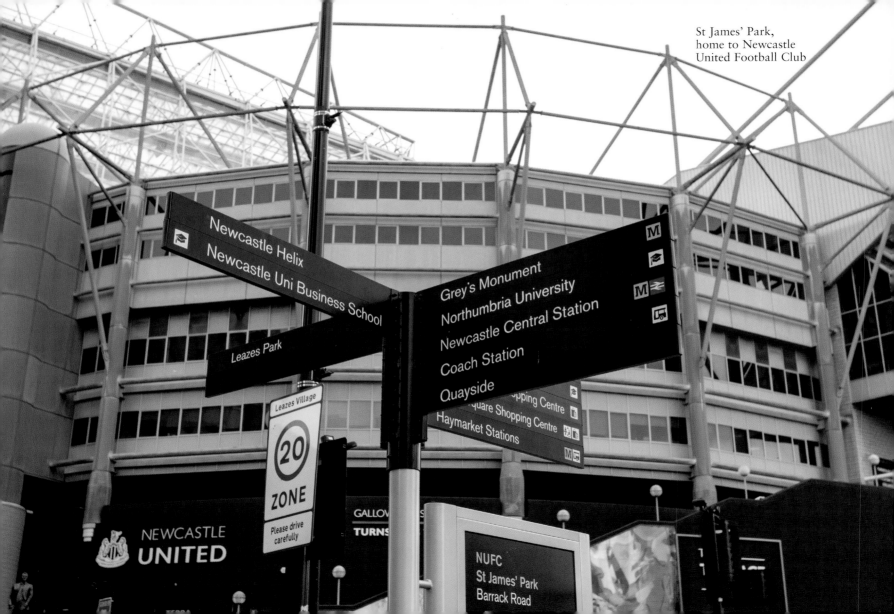

St James' Park, home to Newcastle United Football Club

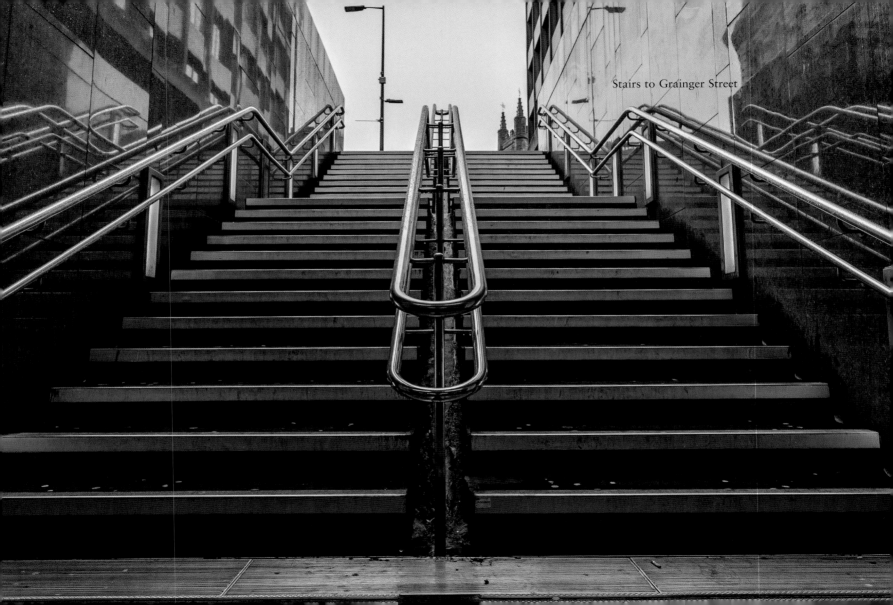

Stairs to Grainger Street

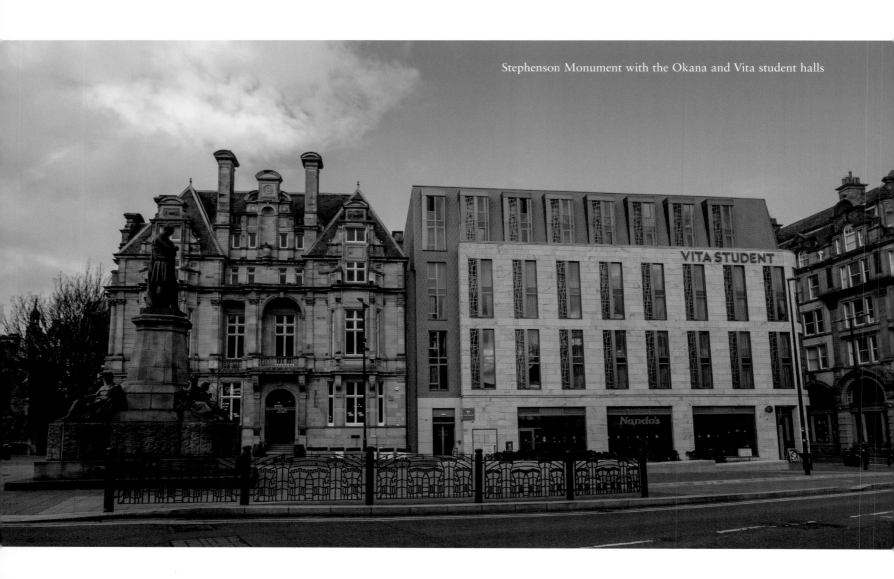
Stephenson Monument with the Okana and Vita student halls

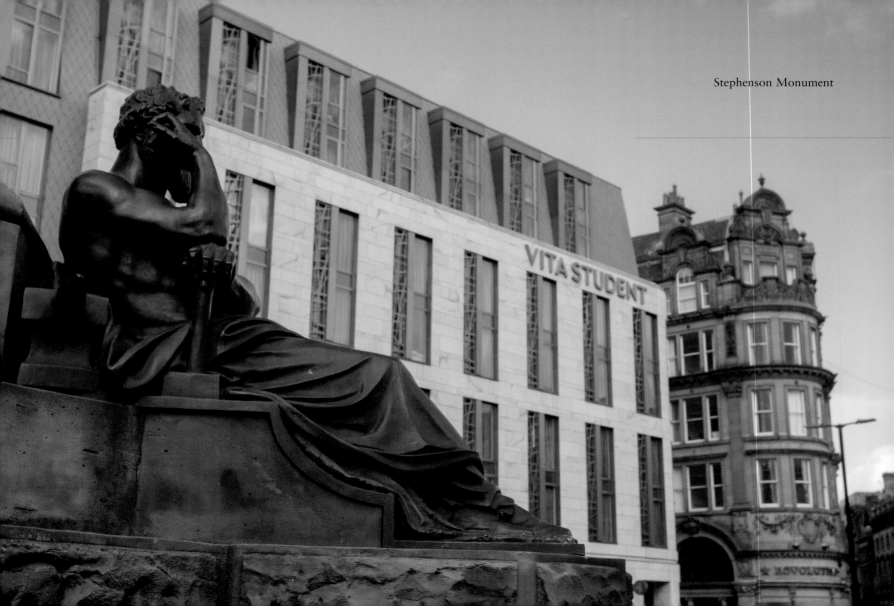

Strawberry Place

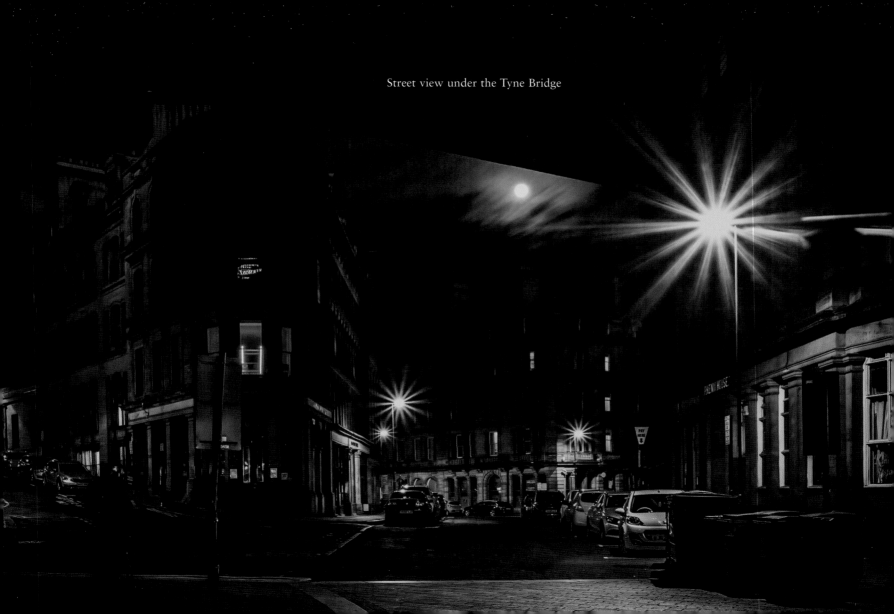
Street view under the Tyne Bridge

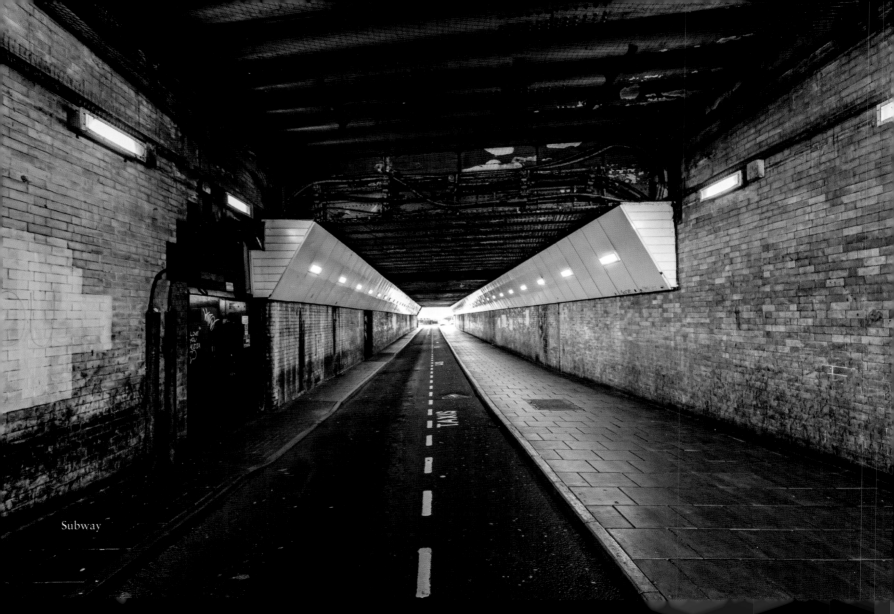

Subway

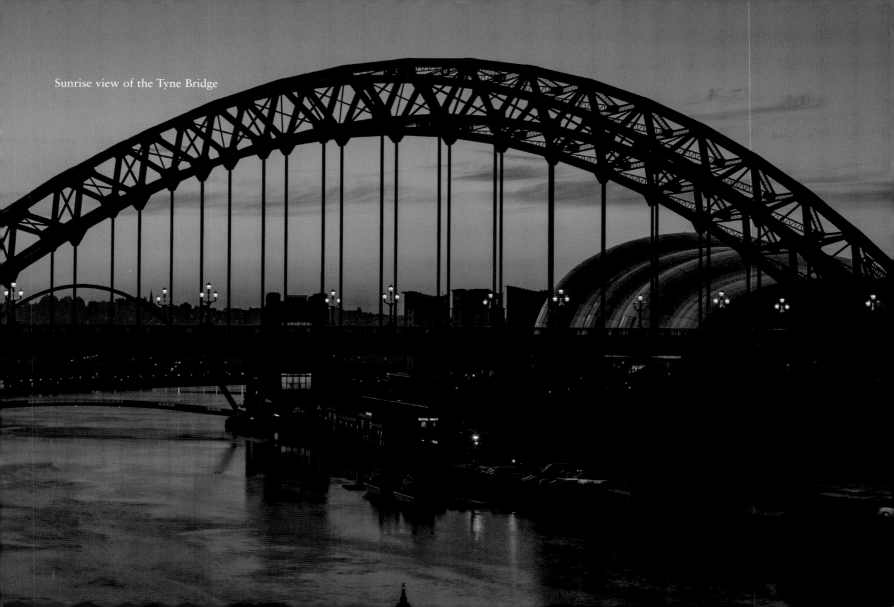
Sunrise view of the Tyne Bridge

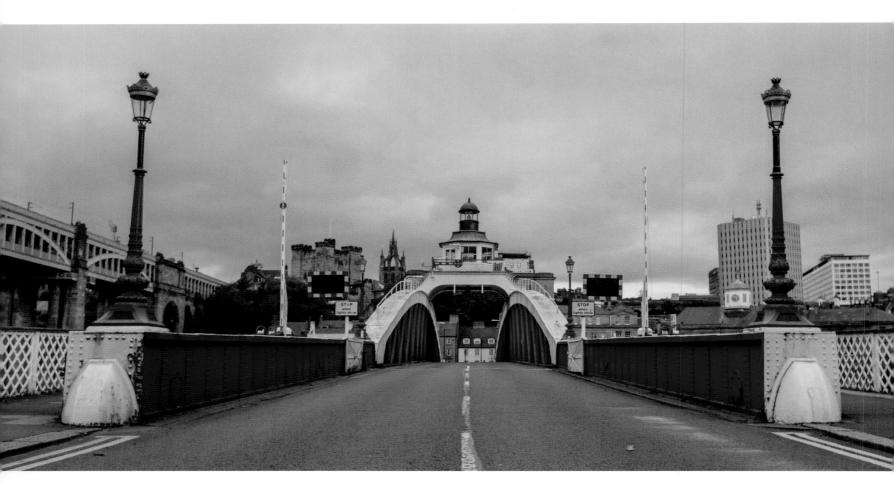

Swing Bridge

The Back Page

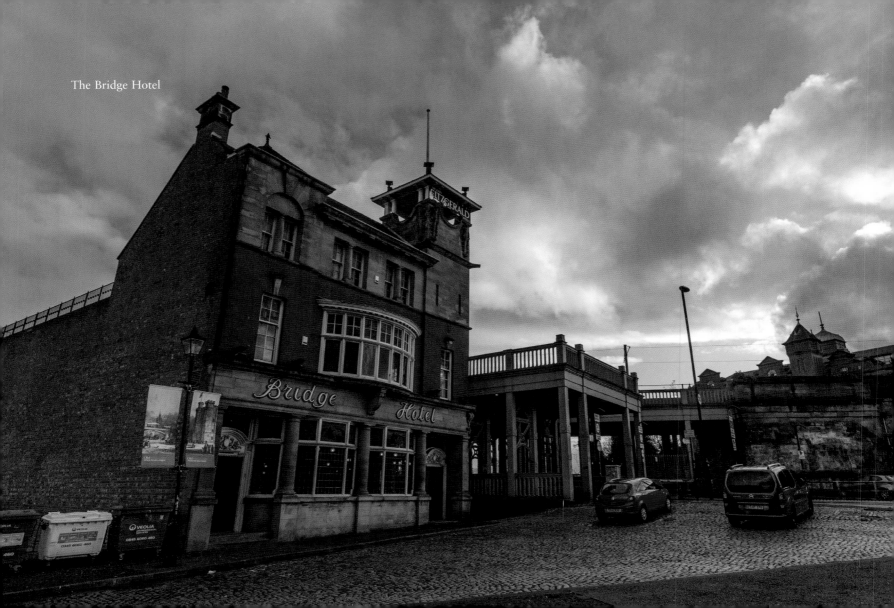

The Bridge Hotel

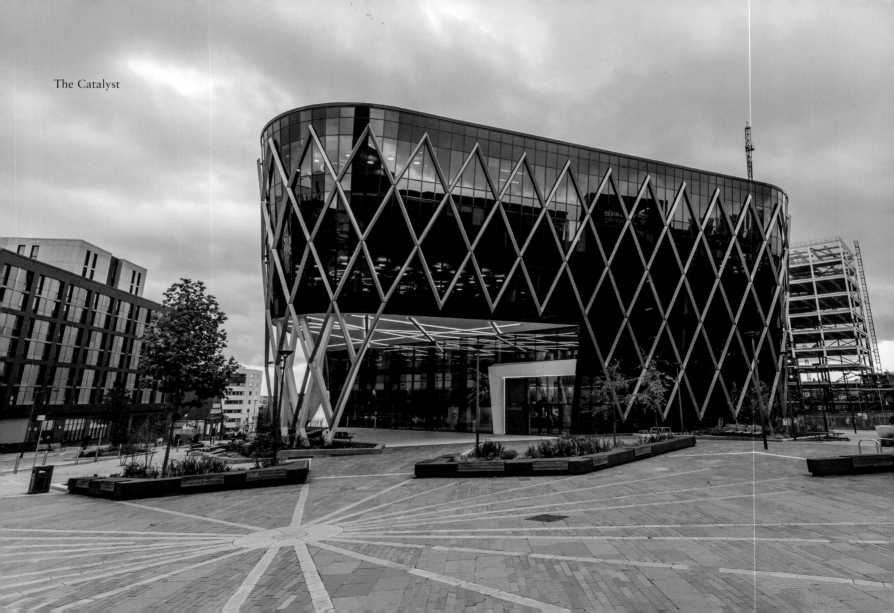

The Catalyst

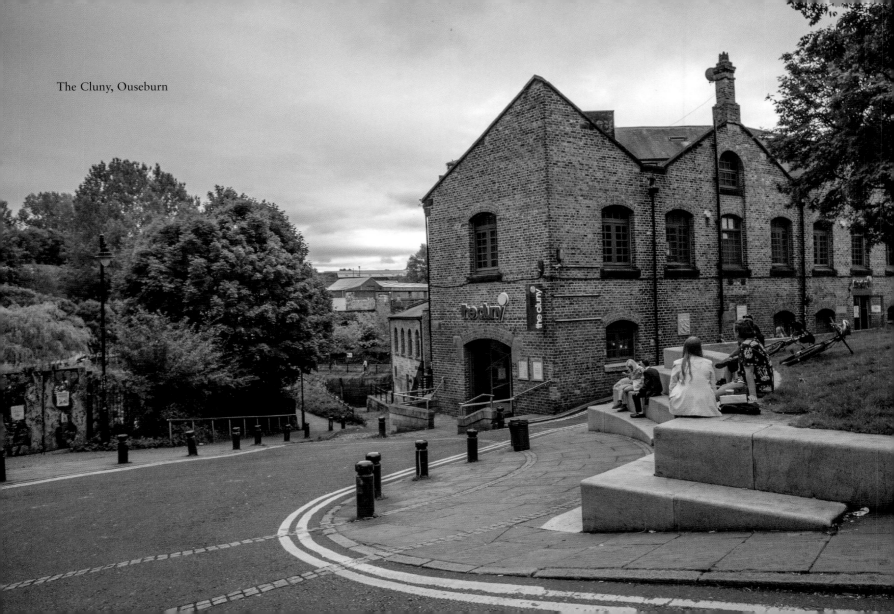

The Cluny, Ouseburn

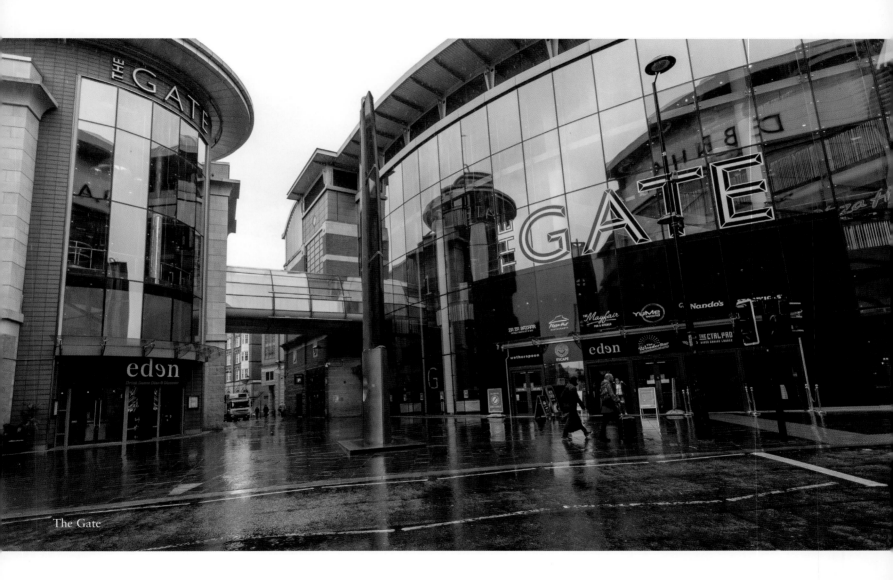

The Gate

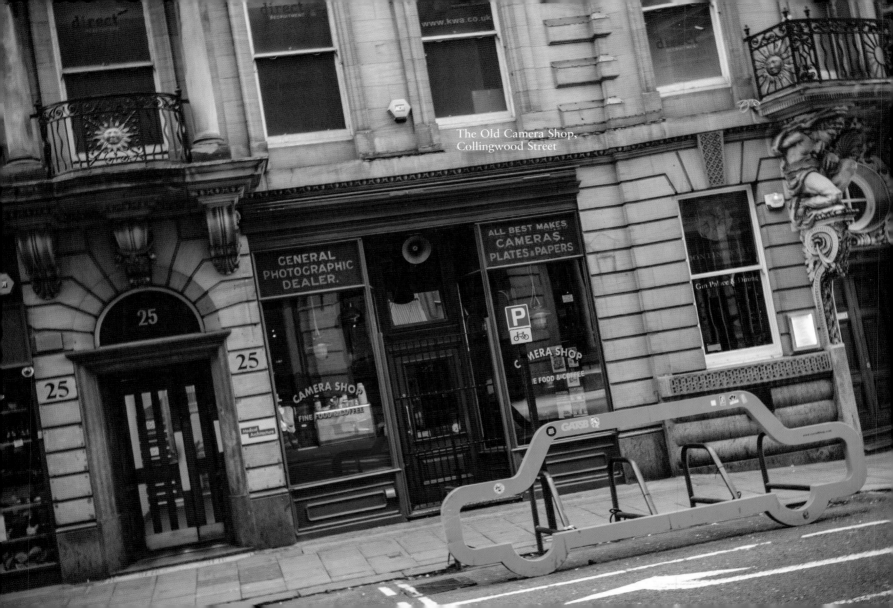

The Old Camera Shop,
Collingwood Street

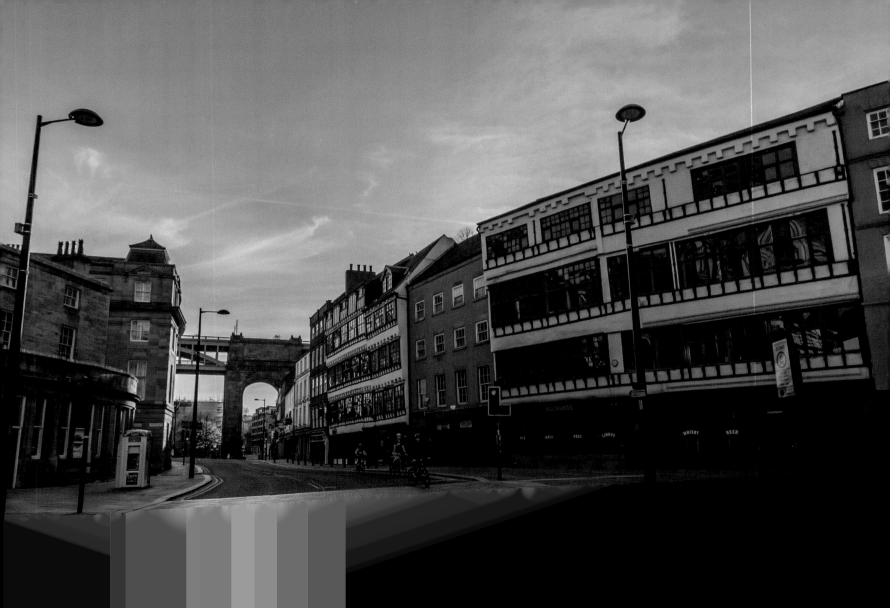

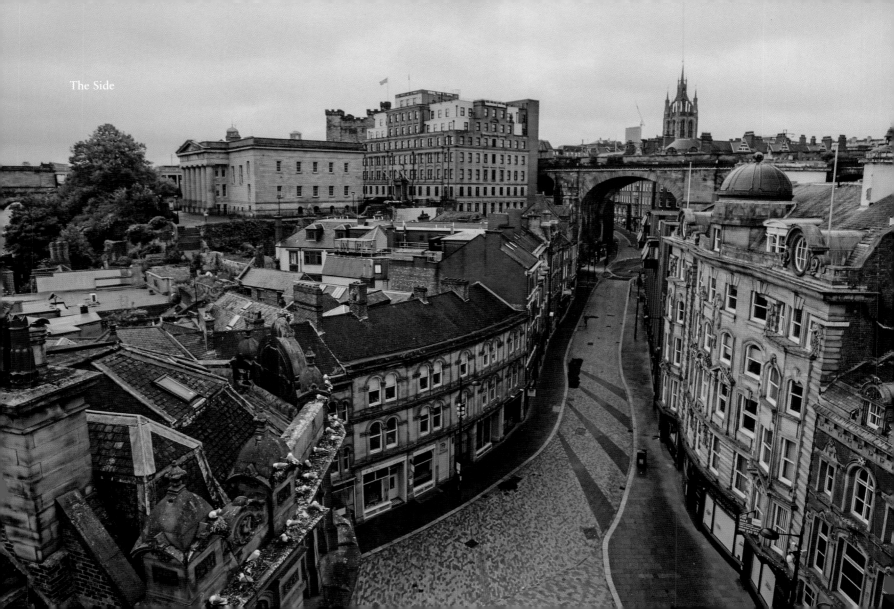

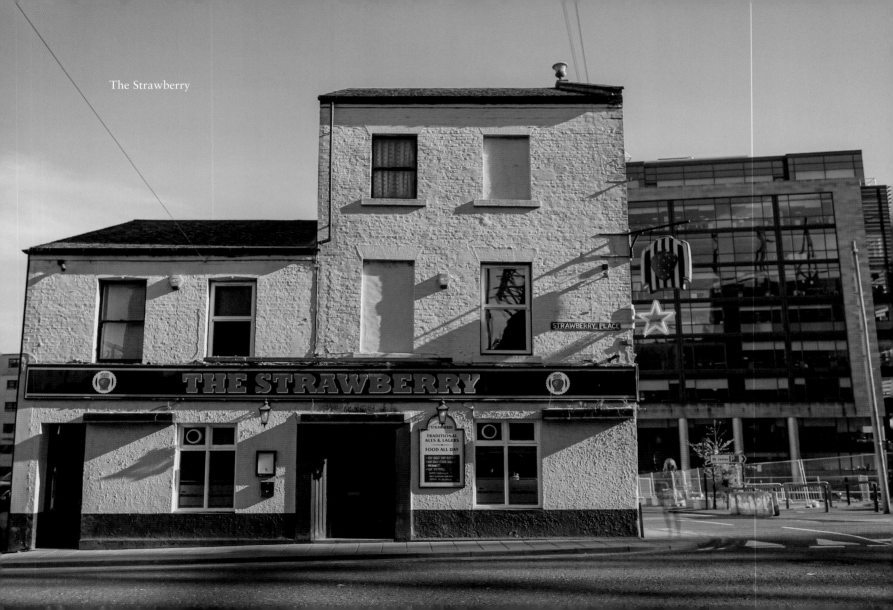

The Strawberry

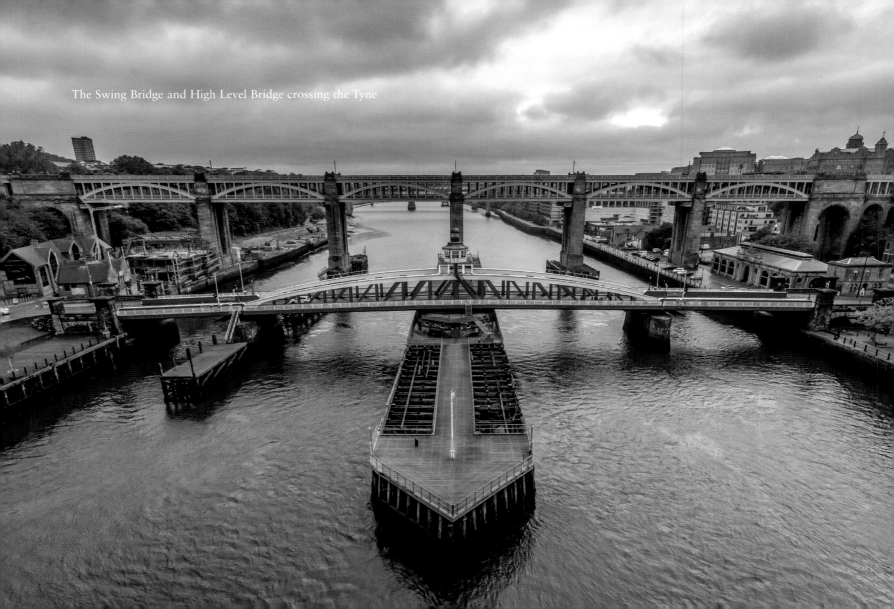

The Swing Bridge and High Level Bridge crossing the Tyne

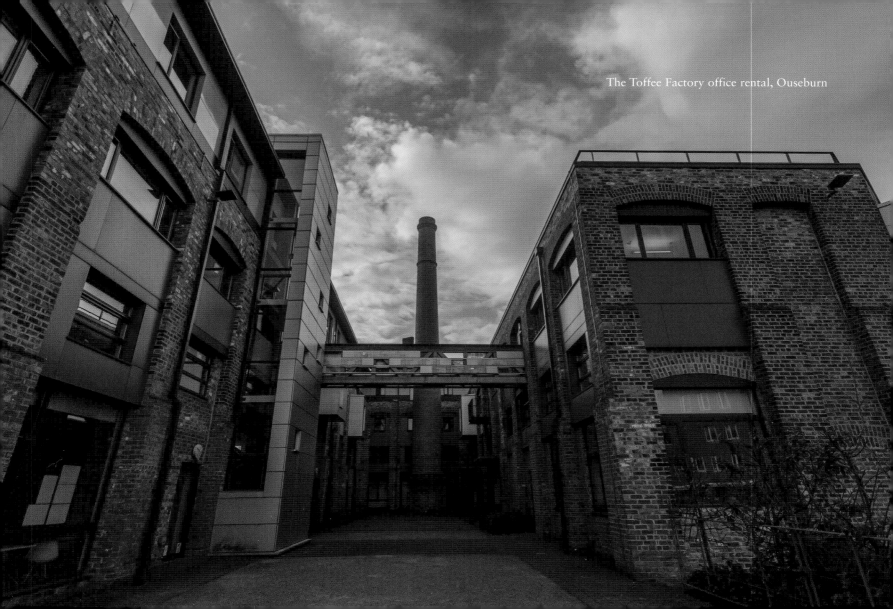

The Toffee Factory office rental, Ouseburn

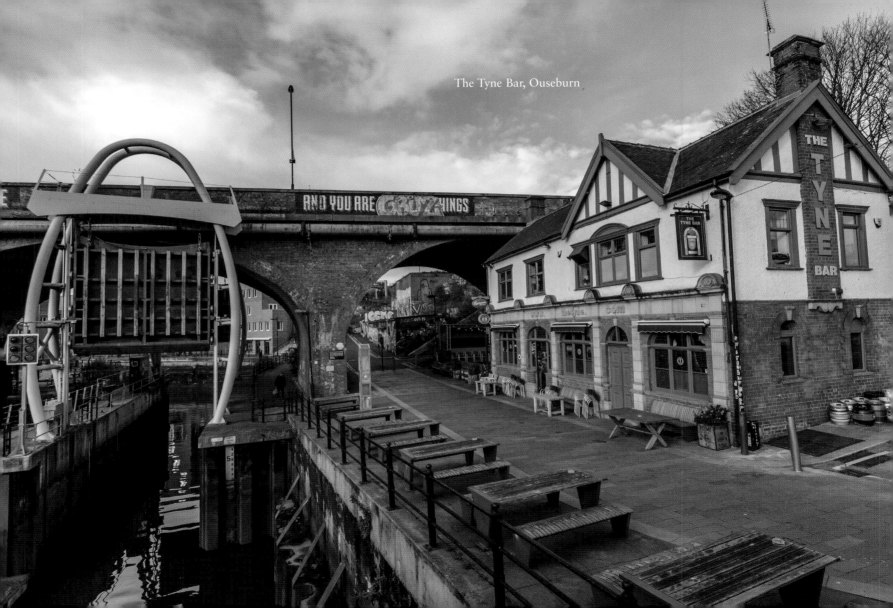

The Tyne Bar, Ouseburn

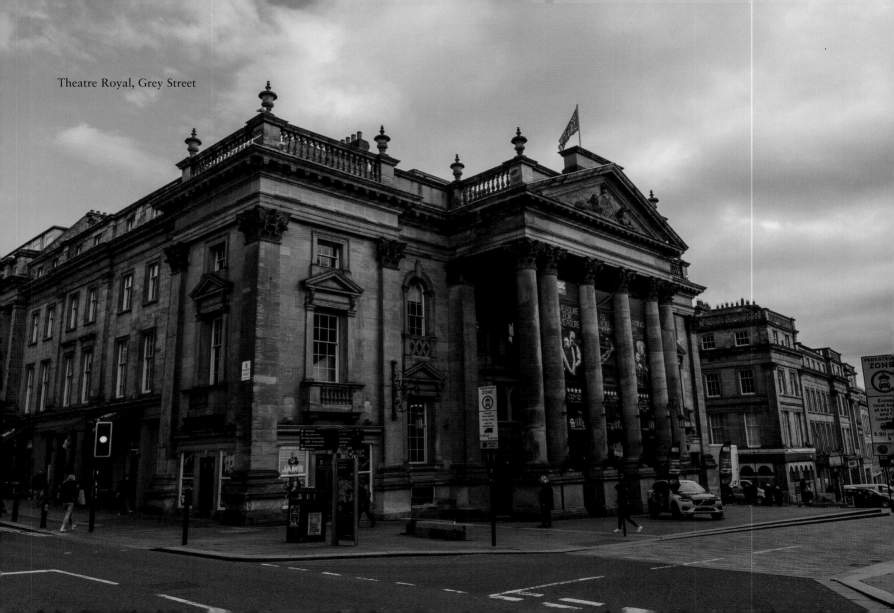

Theatre Royal, Grey Street

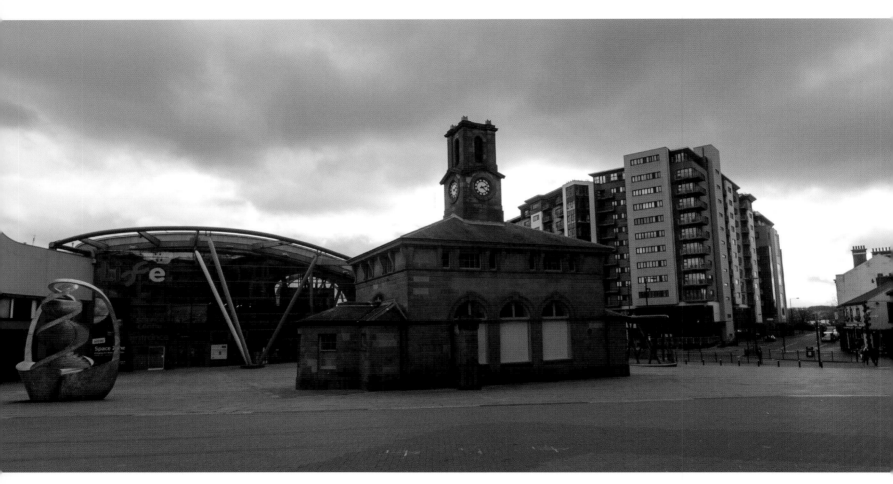

Times Square

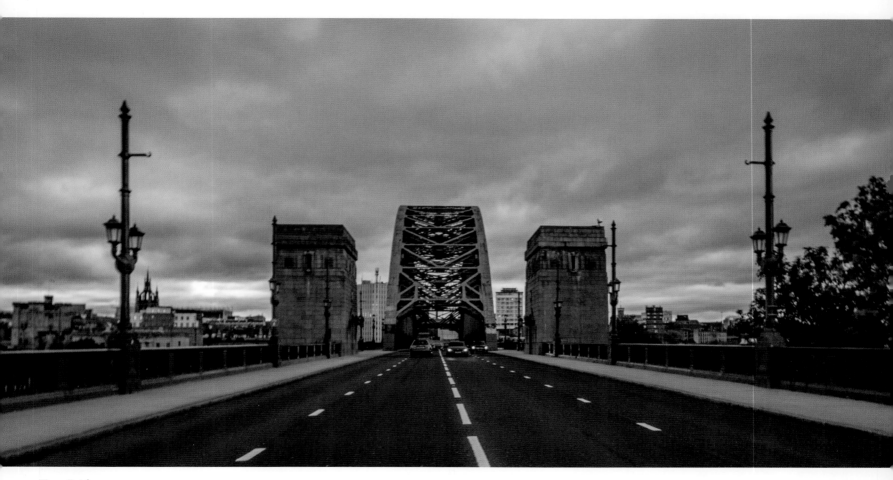

Tyne Bridge

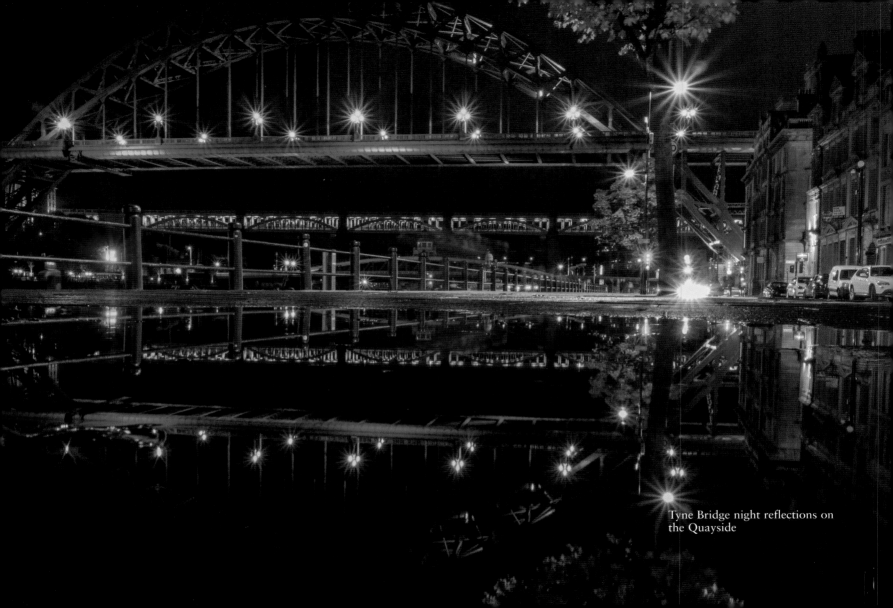

Tyne Bridge night reflections on the Quayside

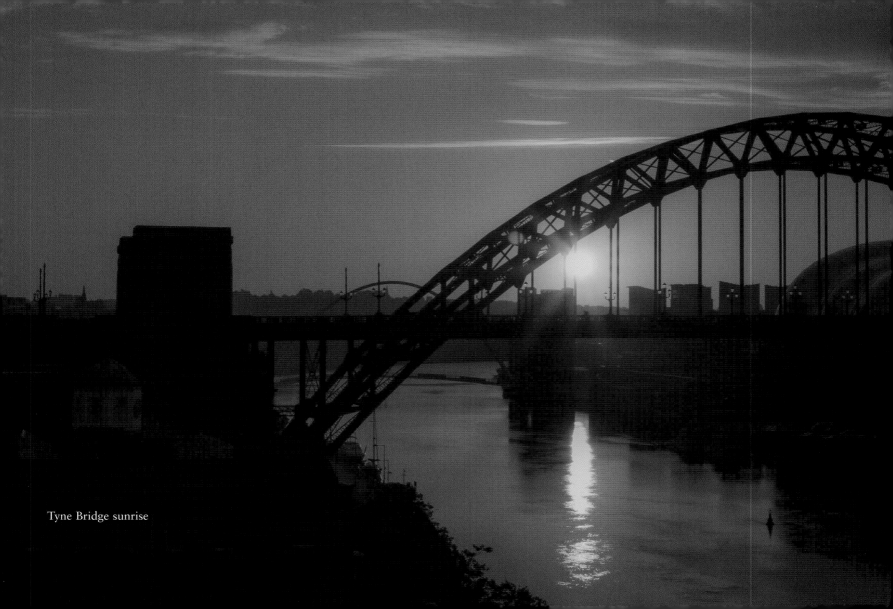

Tyne Bridge sunrise

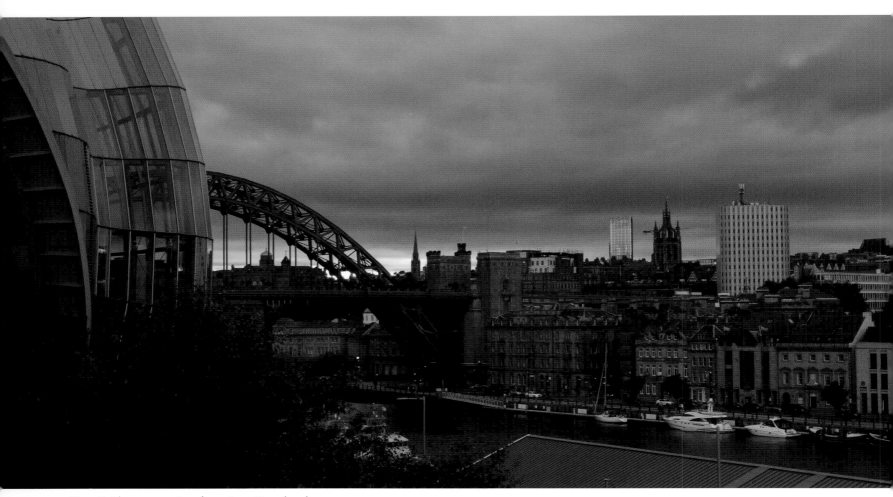

Tyne Bridge sunset view from Sage Gateshead

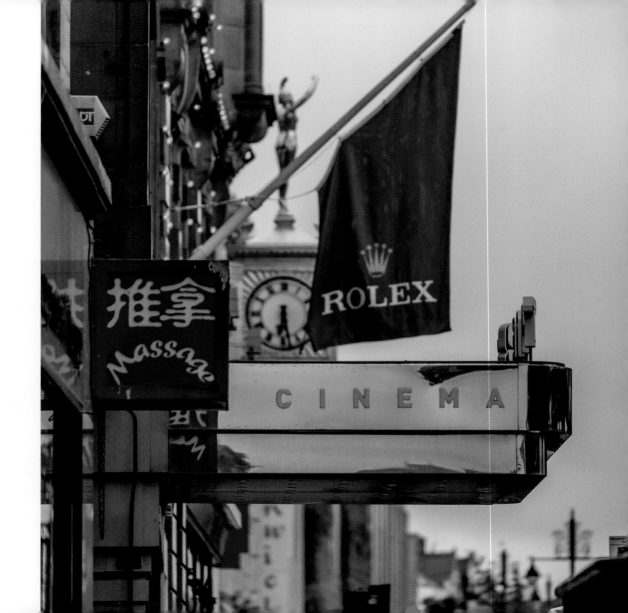

Tyneside Cinema, Pilgrim Street

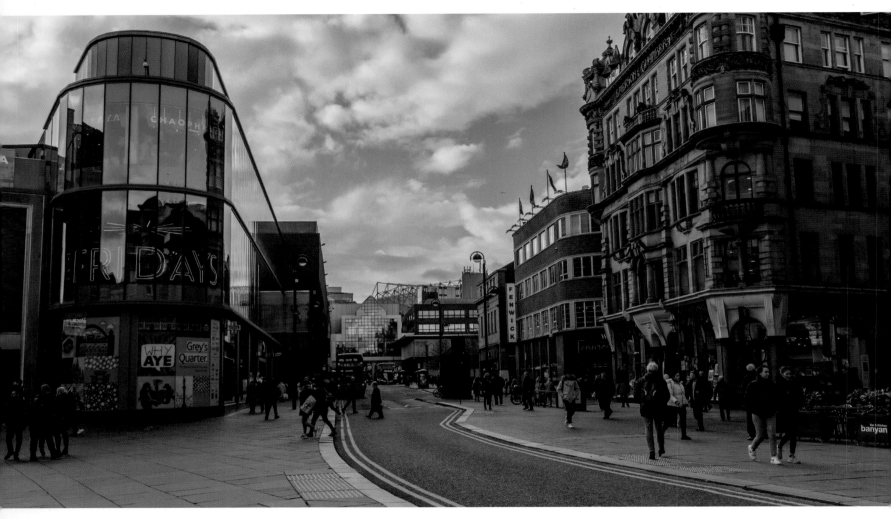

View down Blackett Street

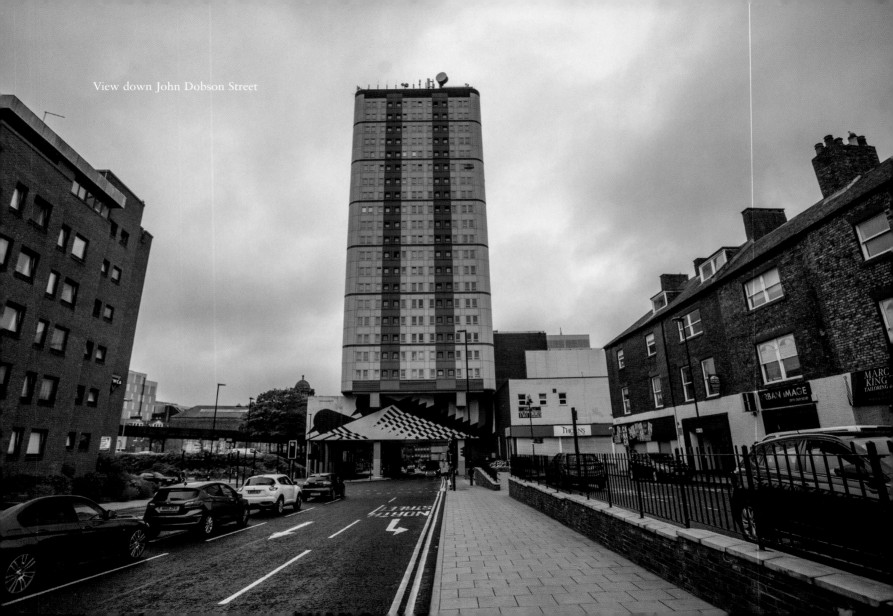
View down John Dobson Street

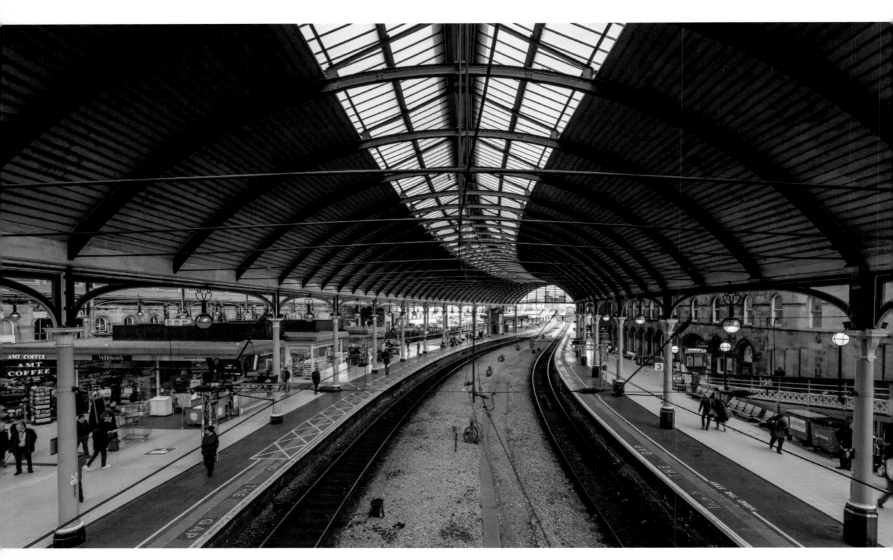

View down the tracks at Central station

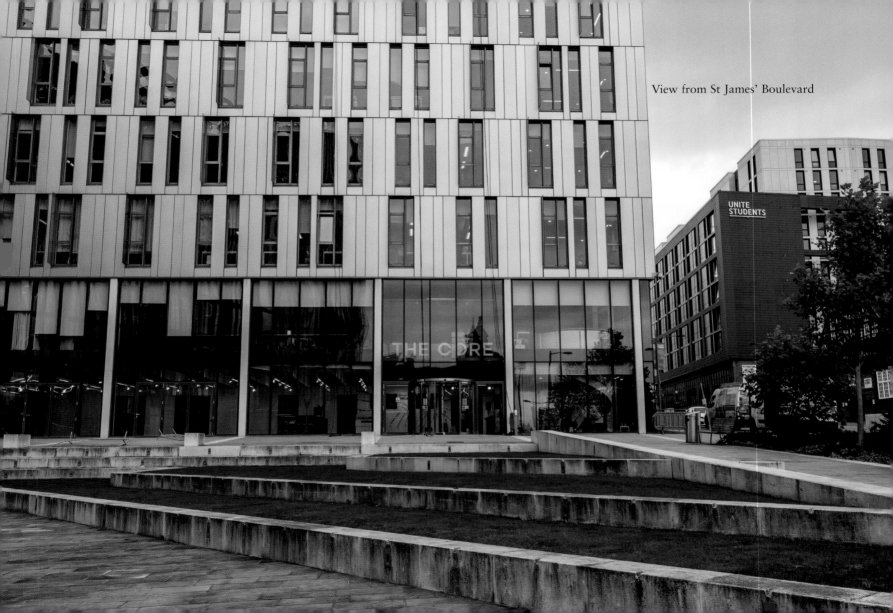

View from St James' Boulevard

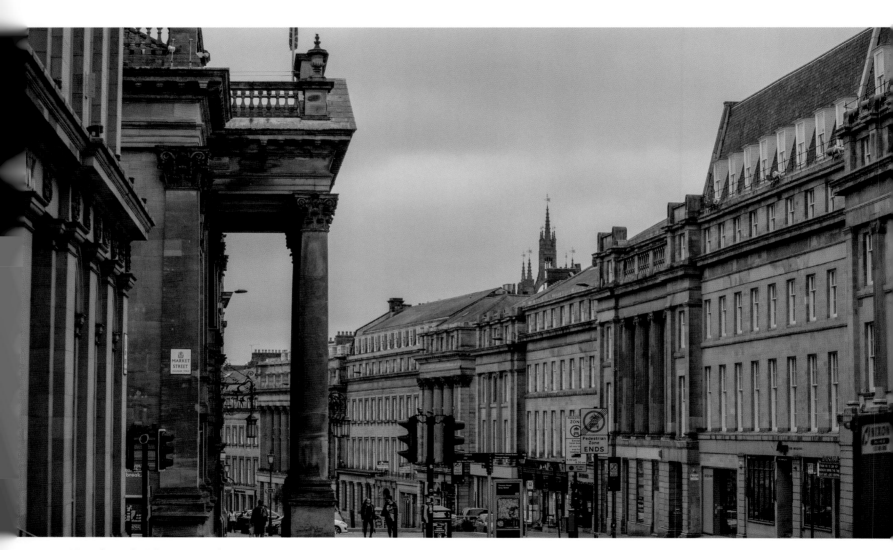

View from the Theatre Royal, Grey Street

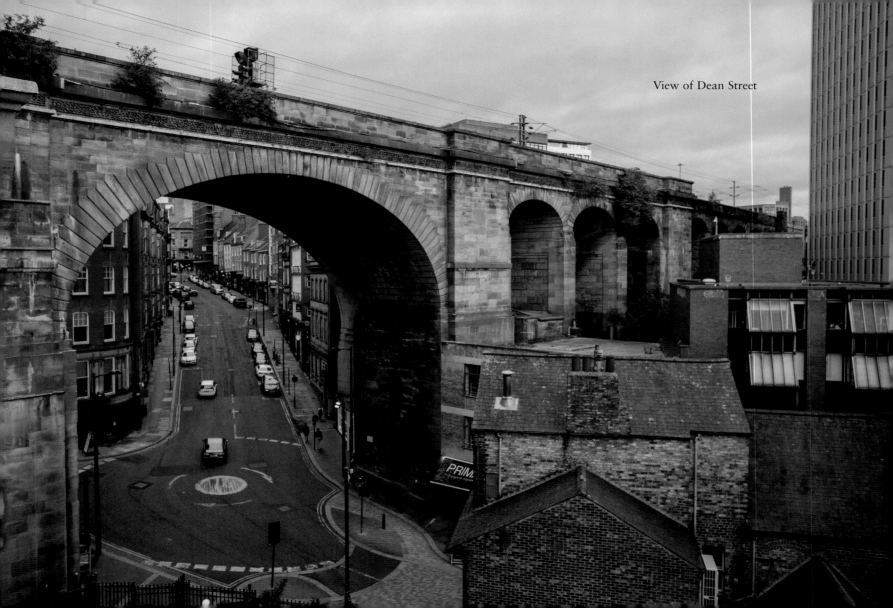

View of Dean Street

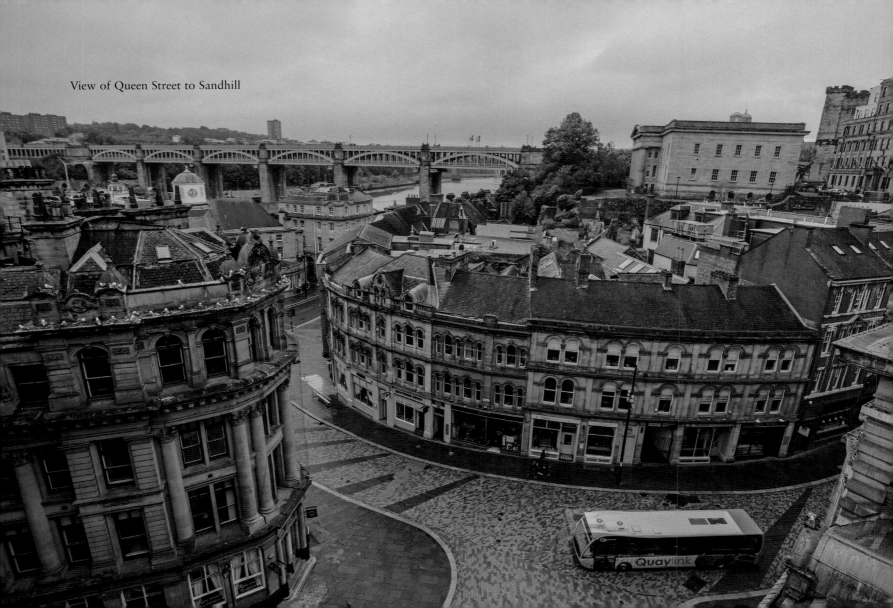

View of Queen Street to Sandhill

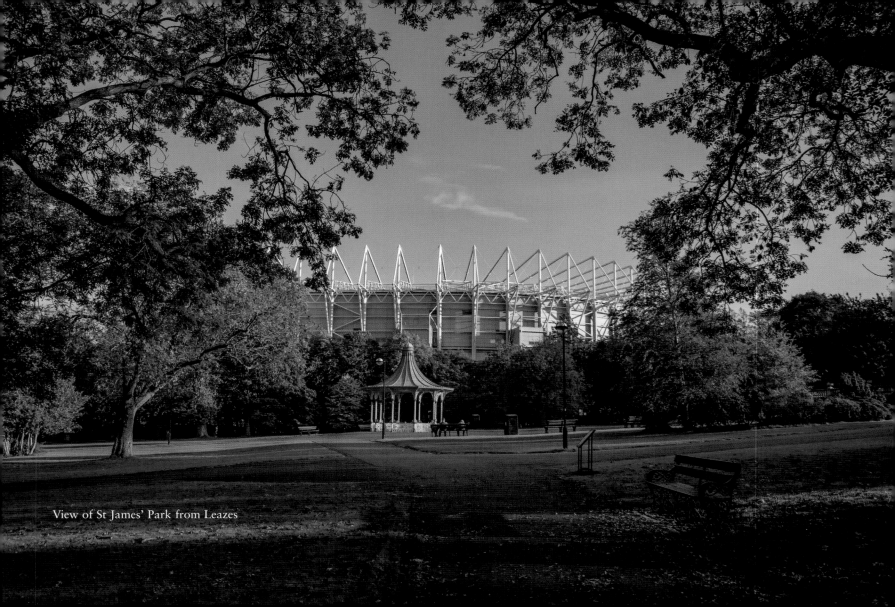

View of St James' Park from Leazes

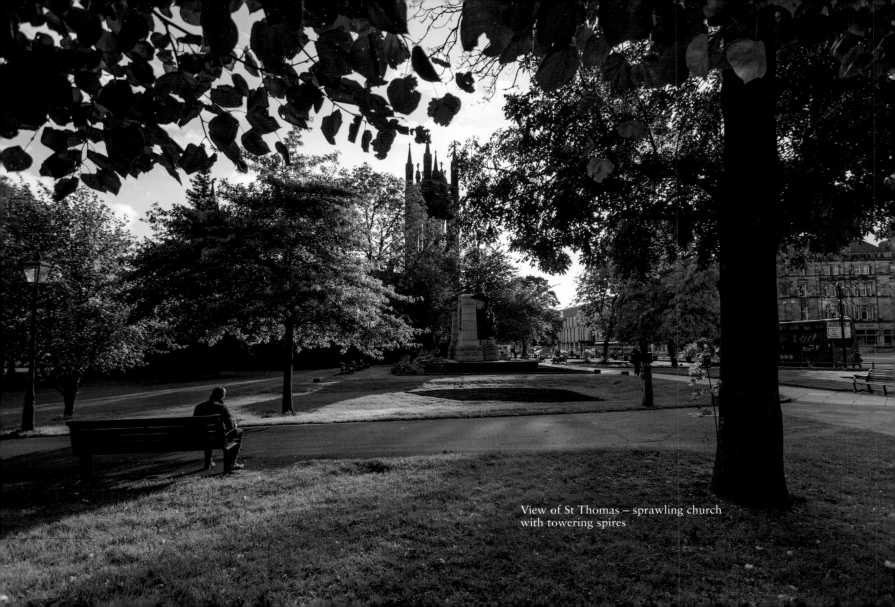

View of St Thomas – sprawling church
with towering spires

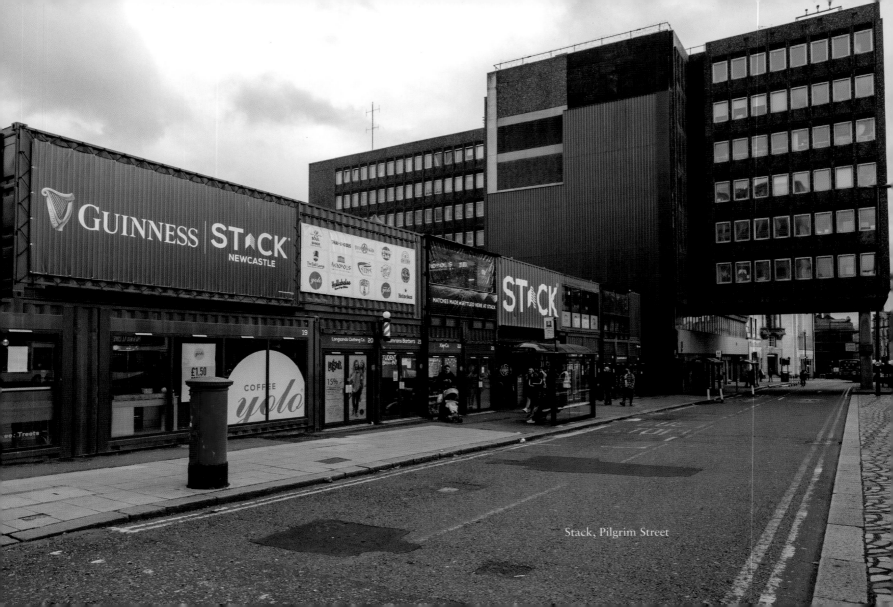

Stack, Pilgrim Street

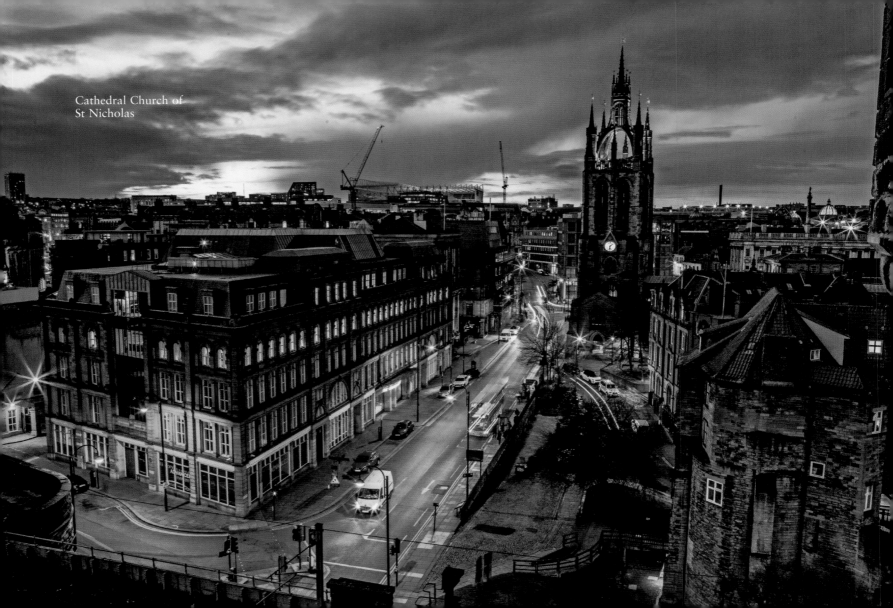
Cathedral Church of
St Nicholas

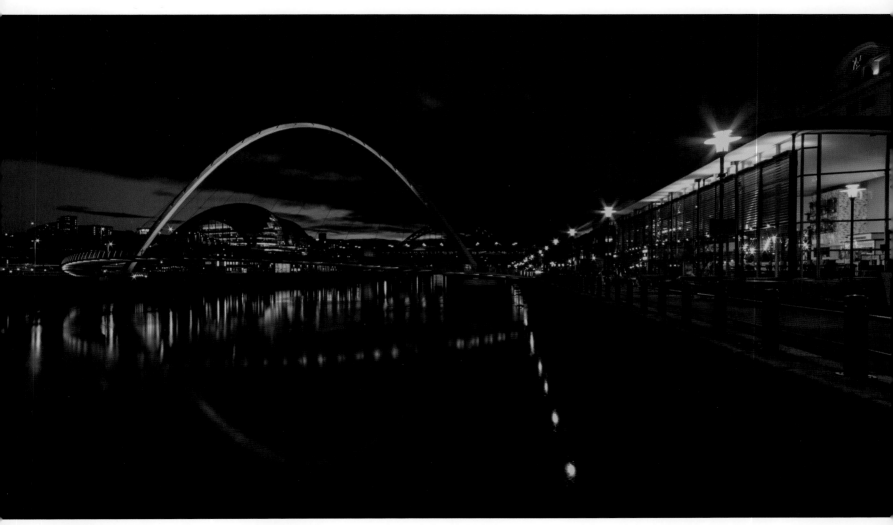

View of the Sage Gateshead from Newcastle Quayside

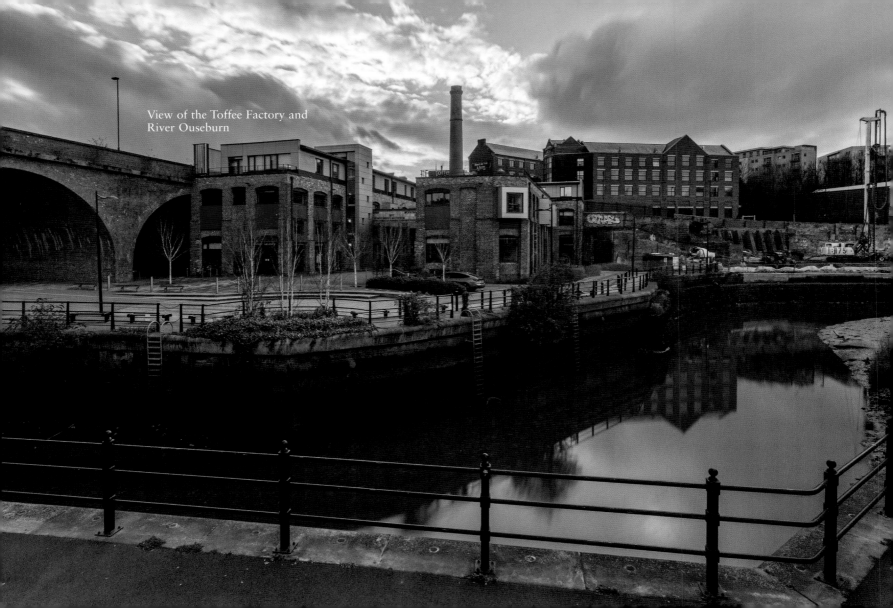

View of the Toffee Factory and
River Ouseburn

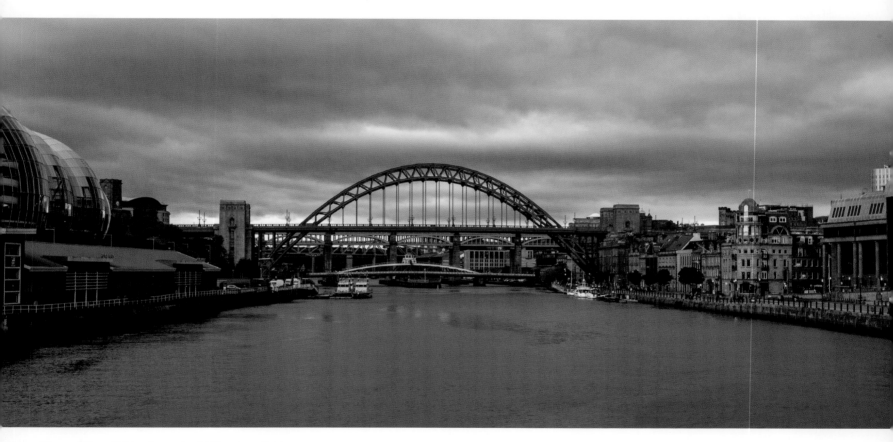

View of Tyne Bridge from the Millennium Bridge

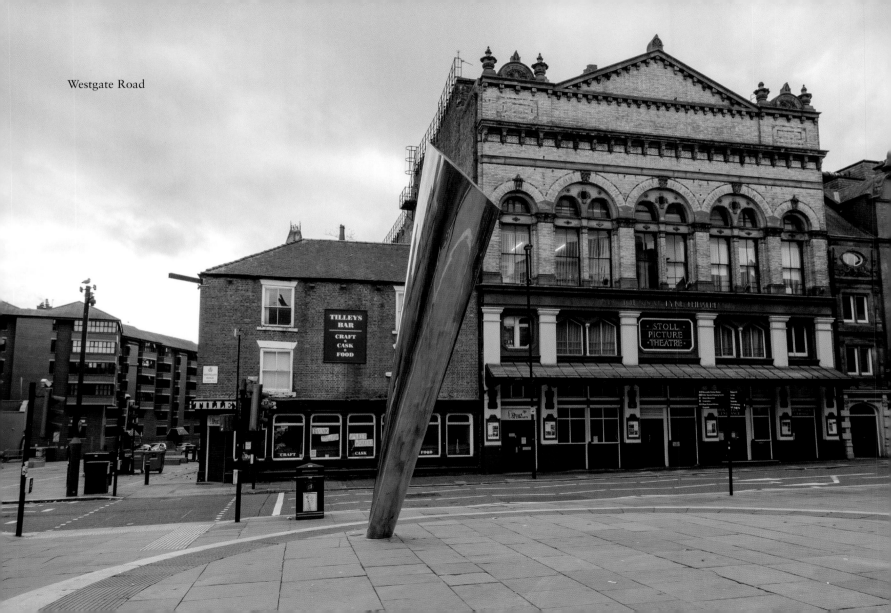

Westgate Road

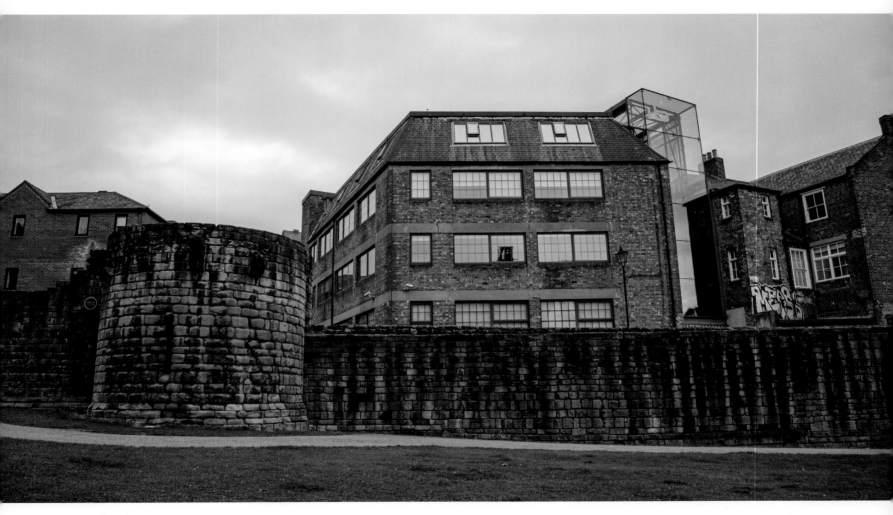

West Walls, Chinatown

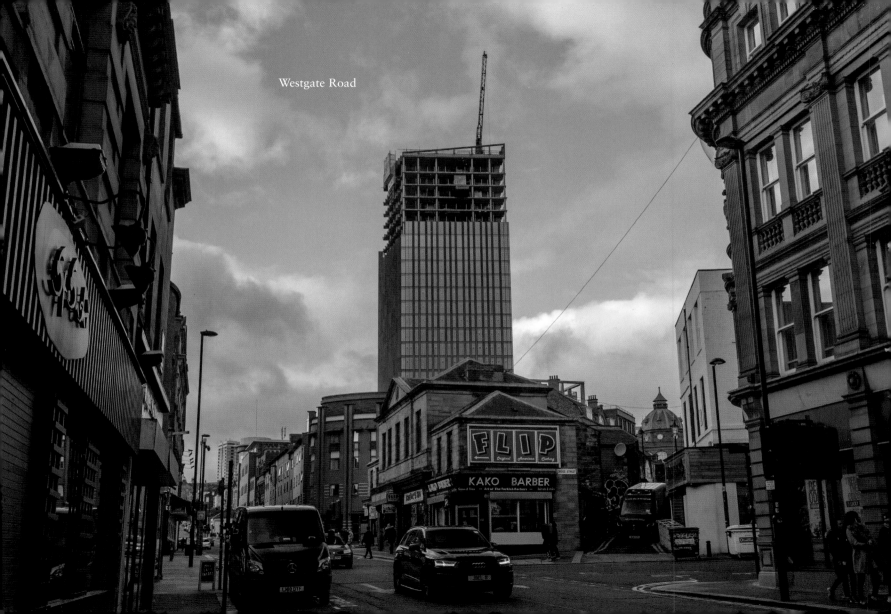

Westgate Road

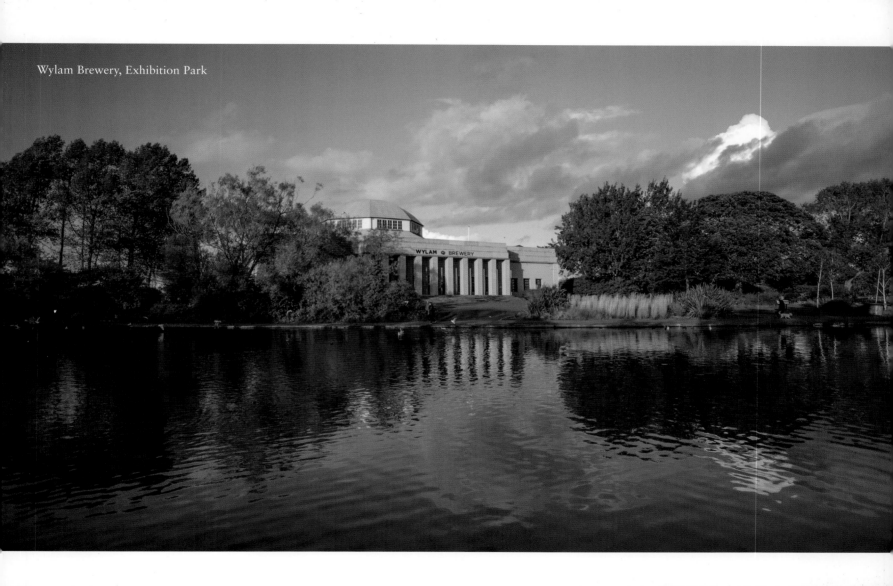

Wylam Brewery, Exhibition Park

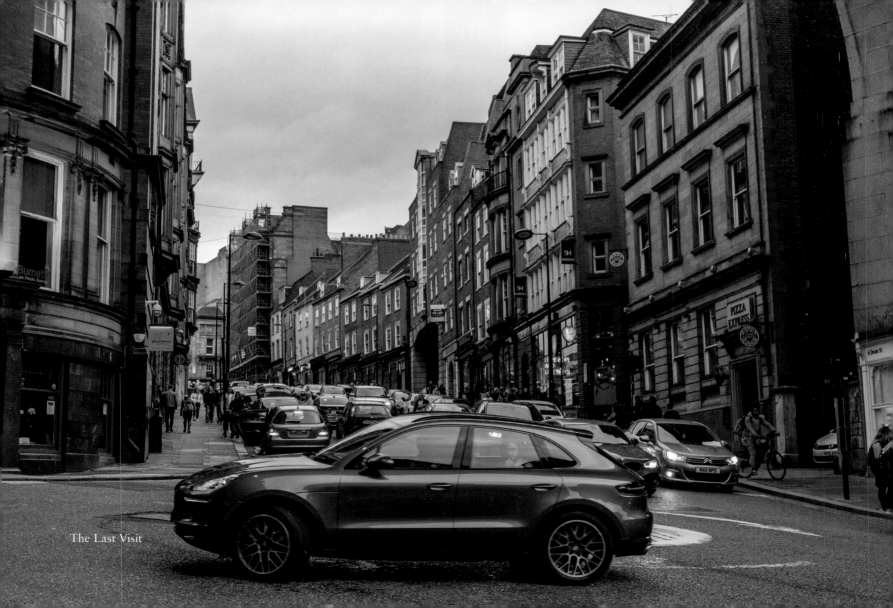

The Last Visit